Table of Contents

ABOUT THE COVERS

The bisque figures of a turn-of-the-century portrait photographer making an exposure of his subjects (uncapping the lens was the most reliable method then) were made by sculptor John Rogers in the year 1878.

Reproduced by the kindness of the International Museum of Photography at George Eastman House, Rochester, N.Y.

The tools of the portrait trade have evolved drastically over the years. However, no matter how advanced the hardware becomes, portraiture will always be a field for artists of a sensitive and inquiring nature, with a love of beauty and a very special feeling for people as individuals; for without these qualities, pictures are merely images on film and paper, not the definitive photographic descriptions called portraits.

And here, on the back cover, is what it is all about in modern portrait photography. A technically excellent and esthetically pleasing picture, beautifully framed into a package that gives satisfaction to its creator and generates love and affection in those that give and receive it. It is by Paul Ness, Coordinator of Portrait Markets, Professional and Finishing Markets Division of Eastman Kodak Company, whose job it is to help you in every way to become a successful photographer. We present it with no little pride.

About the Illustrations

As with all facets of modern civilization, taste and fashions change constantly in the field of portrait photography, yet the basic principles remain constant.

The illustrations in this Data Book are entirely the work of professional photographers presently earning their living in the field.

A number of pictures, illustrating such points as camera height, basic lighting, and make-up application, were produced by the Photographic Illustration Department of Kodak. The majority of the pictures, however, were made by portrait photographers in their studios or on location in their own territories.

The illustrations were selected, with difficulty, from literally thousands of pictures submitted by the Kodak Professional Technical Sales Representatives who cover the world. These TSRs are justly proud of "their" photographers' work. We, too, feel that no one can teach by example better than those who are making a living by producing salable photographic portraits.

For their willingness to share their ideas and techniques with the profession, our heartfelt thanks go to the artists listed alphabetically below.

Dave Allison
Pekin, Illinois

Peder Austrud
Mandal, Norway

Roger Bester
New York, New York

Don Blair
Murray, Utah

Hans Jorgen Brun
Bergen, Norway

Carlos Bueso
Villa Dos Pinos, Puerto Rico

Louis Burger
Zurich, Switzerland

Fred Burrell
New York, New York

Sam Campanaro
Rochester, New York

Gabriel Comtet
Bourg en Bresse, France

Phil Condax
Rochester, New York

Ralph Cowan
Chicago, Illinois

Edward A. DeCroce
Denver, Colorado

Ernie Curtis
Oklahoma City, Oklahoma

Jacques Degen
La Neuveville, Switzerland

Christopher DerManuelian
San Mateo, California

Rick Dinoian
Livonia, Michigan

Delores Flores
Mexico City, Mexico

Theo Germann
Utrecht, The Netherlands

Henk Gerritsen
Oosterbeek, The Netherlands

Al Gilbert
Toronto, Canada

Steven Goldman
West Hartford, Connecticut

Erich Muller-Grunitz
Aschaffenburg, Germany

Rocky Gunn
Van Nuys, California

Preston Haskell
St. Catherines, Canada

Anthony Henry
Aukland, New Zealand

Joy Henry
Aukland, New Zealand

Hector Herrera
Genova, Mexico

John Howell
Winnetka, Illinois

Jerzi Jakacki
Farmington, Michigan

Rolf Jeck
Basel, Switzerland

John Kasinger
Sunnyside, Washington

Yasutaka Kajiyama
Kiryu, Japan

Leon Kennamer
Guntersville, Alabama

Y. Kobayashi
Kyoto, Japan

Keigo Kohno
Kyoto, Japan

Max Koot
Den Haag, The Netherlands

Studio Kuvasiskot
Helsinki, Finland

David LaClaire
Grand Rapids, Michigan

Linda Lapp
Sherwood, Oregon

Pat Lasko
Chicago, Illinois

Raymond Leroux
Villeneuve d'Ascq, France

Ray Lester
Norwood, South Australia

Saburo Masaki
Kumamoto, Japan

Paul Ness
Rochester, New York

Jack Newsom
Albuquerque, New Mexico

Hubert Oger
Nantes, France

Takashi Ogishima
Tokyo, Japan

Hichiro Ouchi
Himeji, Japan

Stanley Gordon Richards
Campbelltown, South Australia

Silvio Rone
Toledo, Ohio

M. Sawada
Tokyo, Japan

S. Schuhmacher
Agno, Switzerland

Riukichi Shibuya
Tokyo, Japan

Michael Sibthorpe
Windsor, England

Jay Stock
Martins Ferry, Ohio

M. Takemori
Tokyo, Japan

John W. Venus
Stirling, South Australia

Julien Vergauwe
St. Laureins, Belgium

Juan Villaplana
Manresa, Spain

Damien Waring
Honolulu, Hawaii

Kiyoshi Watanabe
Nara, Japan

Ludwig Wunschmann
Stuttgart, Germany

Alo Zanetta
Vacallo, Switzerland

William Ziegler
Menlo Park, California

Monte Zucker
Silver Spring, Maryland

A special note of appreciation is due to the following photographers, technicians, and artists who devoted their time to write the articles about their special fields of endeavor which are included in this book. Alphabetically, they are, Fred Burrell, Rocky Gunn, Leon Kennamer, David LaClaire, Linda Lapp, Jim McDonald (for much of the technical information and the KODAK Light-Ratio Calculator and the KODAK Light-Ratio Reflectance Cards), the Photosisters, and Rosa Russell.

Reasons for Becoming a Portrait Photographer

When we began the task of preparing the first edition of Professional Portrait Techniques, we started a search for examples of good, honest, modern portraiture. As we spoke to photographers across the country about their work, we also asked them, "What made you decide to become a portrait photographer?" The answers were amazing in their variety and bear repeating here in the second edition. Some photographers said that they were fulfilling a need, since anywhere there are people there is a demand for portraits.

Others said that it's nice to be your own boss with your own business; you have more chance for creativity, you can develop your business to the level you wish, you can pick your own market, you have a large audience, you have a higher prestige in the community than most, and you work constantly with people. One man, with a sense of history, mentioned Brady's Lincoln portraits and hoped to make a similar contribution to society. None said that it is easy work. But the answer we liked best was in the form of another question: "What other profession do you know that gives as much happiness to so many people?" Think about it.

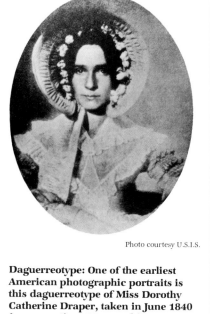

Photo courtesy U.S.I.S.

Daguerreotype: One of the earliest American photographic portraits is this daguerreotype of Miss Dorothy Catherine Draper, taken in June 1840 (exposure time 65 seconds). It was taken by her brother, Dr. J. W. Draper, a professor at New York University.

INTRODUCTION

In the photographic medium, the style of posing the portrait subject has changed constantly through the years.

The limitations of the early sensitized plates — exposures ranged from 30 minutes down to 8 minutes (on a clear day), making neck clamps and carefully braced elbows imperative — left a record of a grim-looking generation. The need for intense illumination precluded the use of artificial light, so the portraits of that era are a joy of simple, single-source daylighting.

As the state of the science of photography progressed, more liberties were taken with the art of photographic portraiture. Faster collodion wet plates allowed the location photographers of the 1860s to cover the American Civil War in the field, using instantaneous exposures to capture the expressions of the nation's leaders. They also permitted portrait studies in gardens and conservatories. The horse-drawn darkroom, necessary for coating and developing of these wet plates, was a familiar sight as portraits in the home became the fashion.

In 1879 the invention of the incandescent lamp opened a new field of lighting for portrait photographers. Soon thousands of watts of light (and heat) recorded the steaming countenances of yet another generation in silver. However, the gelatin emulsions on flexible film base were fast, so the torture of the head brace was a thing of the past.

Today, electronic flash, multi-element coated lenses, and color negative film — technological miracles in themselves — are combined so that one photographer can produce lifelike and natural photographs of more sitters in one day than Dr. Draper and his colleagues captured in their lifetimes.

Psychology

Leonardo da Vinci said of his successful portrait painting: "You do not paint features; you paint what is in the mind."

Four hundred years later Paul L. Anderson wrote in THE FINE ART OF PHOTOGRAPHY (1919): *"The fundamental purpose of portraiture is to furnish a complete and satisfactory likeness of the sitter—the true portrait, then, should present a complete and satisfactory representation of the contours and graduations of the face; it should be as fully descriptive as possible of the sitter's character; and it should be a picture of such nature as to be artistically pleasing to one who is unacquainted with the original—the best portraitist is the one who combines in fullest measure the power of reading character, knowledge of the effects of light and shadow, and mastery of the techniques of his medium, and it necessarily follows that no one ever passes the need for study."*

The dedicated portrait photographer never goes off duty. He practices his trade by studying faces wherever he is. He evaluates the natural lighting on the facial planes of the person across the aisle in a bus. He notes the spotlight effect on the waiter in the restaurant. He thinks in terms of light and shadow, and of contrast, as he studies the face of his next subject when they meet in the reception room. In the studio, before the sitting, he decides which of his subject's features he wants to emphasize before he even selects his props, camera, and lenses. Perhaps a fleeting smile or quick glance dictates a mobile camera, a fast shutter speed, and a strong light. A quiet mood and serious expression could call for a secluded atmosphere, a large-format camera, with natural window light and reflectors. He should be diversified in his equipment so that he can be versatile in characterizing his subject.

Bear in mind that the ordeal of having a formal portrait done is, to many people, one of the most uncomfortable of experiences. The photographer must do everything possible to eliminate this feeling of camera-shyness. One method is to place the sitter in the role of host, in his own home or among the tools of his trade. The least a studio photographer can do to relieve his sitter's tension is to remove him mentally to familiar territory by finding a subject of conversation that he can elaborate upon until the proper expression is captured. Remember that the sitter's state of mind is reflected in his face. The photographer must be more concerned about his subject's feelings than about anything else.

Future Direction

Today the portrait photographer faces a crisis. The tools of his art are sophisticated and reliable. And another dimension—color—has made his image even more realistic and beautiful. But his customer has become accustomed to a world filled with photographic images that visually overwhelm, day and night—pictures that move, talk, and shimmer with brighter-than-life color, created by masters of the camera.

What chance does the portrait stand in this cacophony of photographic advertising? Surprisingly enough, more chance than ever before, given a few creative opportunities. Human nature has not changed. Man is still primarily interested in himself and his own; portraits remain important to him. However, because he has been forcibly educated in the principles of design, color harmony, and composition by the advertising media, he will not accept the static portraits so prevalent in the past.

It has become necessary to start redesigning the portrait for tomorrow, keeping in mind the necessity for building growth into the portrait business of today. To do this, the portrait photographer must innovate as he works. He must accept or reject ideas, depending upon the reaction of his customers. He needs a never-ending flow of informational material on techniques and marketing. Much of this is now available, in one form or another, through the study of modern advertising photography methods, new art forms and uses of color, trends in current consumer publications, by attending seminars and workshops conducted throughout the photographic industry and, finally, by supporting photographers' organizations that stress new ideas and new developments.

Portrait and Message

By the Photosisters — Eila Marjala and Margit Ekman

With all the talk there is today about social involvement and the arts, we easily forget that all art is society-oriented, and always has been. It is merely a question of the attitude art takes to society.

Portraits take an active part in society by confronting the viewer with an individual. We see different people around us all the time in our day-to-day life, but in most cases we do not really see them; we just glance at the surface. We build up an impression of people, and accept one and censure another, and sometimes our attitude is one of merciless unconcern. We all see things in our own way, within the limits of our own powers of observation, colored by our own moods and preconceived ideas. In this case, are we fair to the person we see? Has he not the right to be seen for what he is?

A portrait should show a person as a true and real individual, emphasizing his personality and characteristics. It must be so truthful that not even the subject's own inhibitions and defense mechanisms prevent the deeper layers of his personality from coming out.

"Portrait of a Model: This photo captures the strong personality of Lenita Aviesto, a fashion model who has become known as the Ambassador of Finnish Fashion. She exports our products and holds fashion shows throughout the world. An excellent businesswoman and a television personality, she speaks five languages. A dynamic person, in a very feminine way."

Photographed on KODAK VERICOLOR II Professional Film, Type L, under tungsten studio lights. The kicker lights on each side of the figure were covered with red and magenta gels.

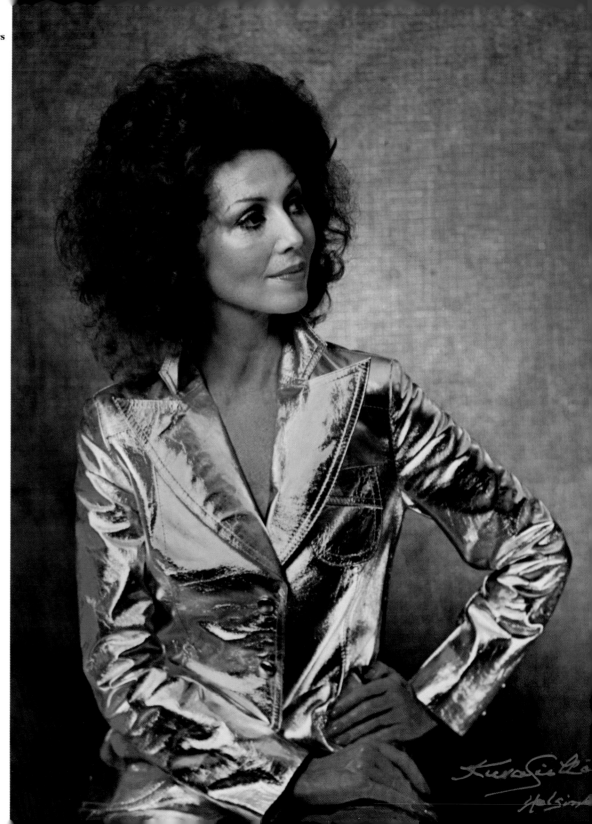

Portrait artists are people too, and they see their subject in their own way. A portrait is, without doubt, a subjective vision of the subject, but the difference between this and the ordinary vision is that the portrait artist is practiced in the art of seeing the personality of her subjects; she has experience providing materials for comparison and she must be able to create contact with her subject as she makes the portrait. And above all, the portrait artist has an intense interest in human beings. Thus she can present her subject in simplified form and from a new angle, revealing new human features.

Technically, the photographer must, of course, be in absolute command of her medium, so that she can forget it completely at the sitting. The photograph is a difficult yet all the more adaptable medium for the portrait, especially now that color is technically no obstacle. The techniques of the photographer differ from those of the painter but are equally expressive and have much more potential for variation. The time when the photograph was regarded as the result of a mechanical operation is history. The photographer's vision determines the result.

The portrait photographer has plenty of scope in selecting her means of expression and style. The art of making portraits has tradition thousands of years old, and it has tried just about every means of portraying man. In each case the artist has to seek the particular means of expression that best brings out the personality of the subject.

Above all, the portrait shows man as an

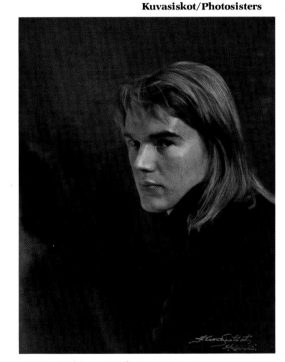

"The Poet in Blue: Before we began the sitting, even, the color blue surrounded him. He worked on the same floor of the office building with us for 10 years. We said, 'Someday, we will do your portrait.' We always saw blue around him. When we made the sitting appointment, we asked him to bring blue costumes. He is a poet, but not a romantic. Rather, he is a realistic and modern writer."

"This is the famous sculptor, Laila Pullinen, a very good and great artist. Known as a protester for social reforms, she has a difficult personality, but we loved her because we, too, know how hard it is for a woman to be successful in this world. She must learn to fight to be able to grow.

"This is an unposed portrait, taken during a discussion, and features the strong hands of the sculptor."

"Purple Dreams: Seppo Saarentola is our photographic assistant. He is a fine assistant, but still just a boy, dreaming boys' dreams and becoming an excellent photographer. He was an amateur and asked to come to work and study with us.

"He had worked with us for several years before we made this portrait, but it took 3 hours before we got this result. It's harder when you know the subject so very well."

Portrait and Message

individual. On the other hand, a portrait collection makes a general impact, giving a picture of the times that will not be seen clearly until decades later. Portraits remain as documents for future generations, both of people and the times. But we should not forget that a portrait always has a sentimental value too.

Perspectives of a Portrait Photographer

In creating a good portrait, the only decisive factor is the professional skill of the portrait photographer. By professional skill, we mean not only the complete technical command of the field, but profound psychological knowledge of a person as well.

The value of a portrait, in our opinion, depends largely on the psychological result. The portrait photographer must continuously train oneself in human psychology in order to make the contact with her subject easy and pleasant. It is not enough to make the subject relax and open up; the photographer must have the subject and the whole situation in full command. Only thus is it possible to produce a pure personal portrait.

In our work we aim at an abstract result where the main purpose is to portray the personality of the subject. In this aim, it is of secondary importance how and where the photographing takes place. The surroundings mean nothing if the objective is a portrait. The discussion about these things should be in this direction.

The portrait photographer must, for these reasons, possess certain mental prerequisites which are inherent and which cannot be learned from books.

In a portrait photograph session, the studio itself must have an atmosphere of comfort and pleasantness to make the subject relax and enjoy the occasion. The most decisive factor, however, is the time factor. For the portrait session both the subject and the photographer must have enough time. Portraits made in too big a hurry are only plain pictures — technically perhaps faultless, but not thoroughly studied works. The result is often intellectually poor.

The photographic techniques, naturally, give many more possibilities for the portraying of a person than, for example, portrait painting. But the same concentrated work is required from the photographer as well. The portrait photographer must be sensitive enough to create the right atmosphere at the very moment when a new client steps into the studio and must instinctively be able to understand the subject's personality as a whole. This is what we mean by professional skill, which separates the portrait photographer from other professionals. A new person is always an extremely interesting challenge — a great adventure! Only thus is created the sensitive contact which results in a favorable photographic session.

It is difficult to know beforehand how long all this will take. Therefore, it is necessary to warn the subject so enough time can be reserved for the session. All photographers have, naturally, their own customs and habits when preparing for the session. But it is most important that there are no restrictions for the one who is aiming at the best possible result. Everything depends on the photographer's own vision and ambition which are the decisive factors in a portrait.

When the subject at the end of a session says, "This was a pleasant and very special happening" or as an 8-year-old girl recently expressed it, "My, what an experience this was!" — then it is a great joy to be a portrait photographer. For ourselves, every session must be — and is — a rich and inspiring experience because it gives us a chance to meet so many people. Many subjects have become our good friends. With most of them close contact continues. Only a few are exceptions.

This all is possible when the technical circumstances are so perfect that they do not disturb the atmosphere. We have our own color laboratory where we can control, adjust, tone, and influence the color at every stage necessary. We can change colors, both on negatives and pictures, with brushes which we use quite a lot.

We work with artificial lights. Incandescent lamps on the ceiling, protected with white diffusion material, give a soft indirect general light. We also have a control table where the voltage is controlled from zero to 260 volts. As we work with the color of light and color filters at different voltages, we are not restricted by fixed background nor by any other standard setting. Lights and colors are determined only by our experience and perception, not by measuring. Our whole work is based on what we see with our eyes. Even the skins of people are different, not to speak of their clothing.

When we thus have both color and light in our full command, the possibilities are unlimited. Technique is our servant, letting us reach our goal. There are no fixed rules — the photographer's own vision is important.

We started in portraiture with the concept that we didn't want color photography to tie us to certain fixed forms. Happily for us, Kodak has, all these years, produced artificial light film which suits our purposes. When the outside circumstances are in our command, we are able to concentrate on the client, discussing with him, exchanging views, in a

manner where the technical adjustments do not disturb him. Furthermore, working as a team of two people we can take advantage of the fact that, while one stands behind the camera, the other handles the discussion with the client, thereby "incidentally" moving the lights here and there, without letting the subject notice much of the technical details. Gradually, he relaxes his features to become himself.

The portrait photographer's profession is difficult, but rewarding. Economically, the field is uncertain because the costs are far greater than those of a portrait painter. This fact is not easily understood because there has been very little general information and discussion about these things. Throughout our years of operation as portrait photographers in Finland we have suffered from this lack of information and understanding which, in effect, has caused this field to be rather underrated.

There are, however, here and there some artistic souls who have accepted the challenge, who are striving for higher valuation of their field by arranging exhibitions and who otherwise struggle to have their works acknowledged as art alongside other already recognized forms of art.

We are grateful for this opportunity to present our views on the perspectives of a portrait photographer.

—One of the most interesting professions in the world.

"Summertime: She arrived dressed in a dark costume. We photographed her in that; then she changed to a light-colored dress and we put up a white background, but her dark hair made a clashing note. Through conversation, we learned of her collection of hats, so at a later date, we photographed her as we visualized her — in white, with this beautiful flowered hat from her collection."

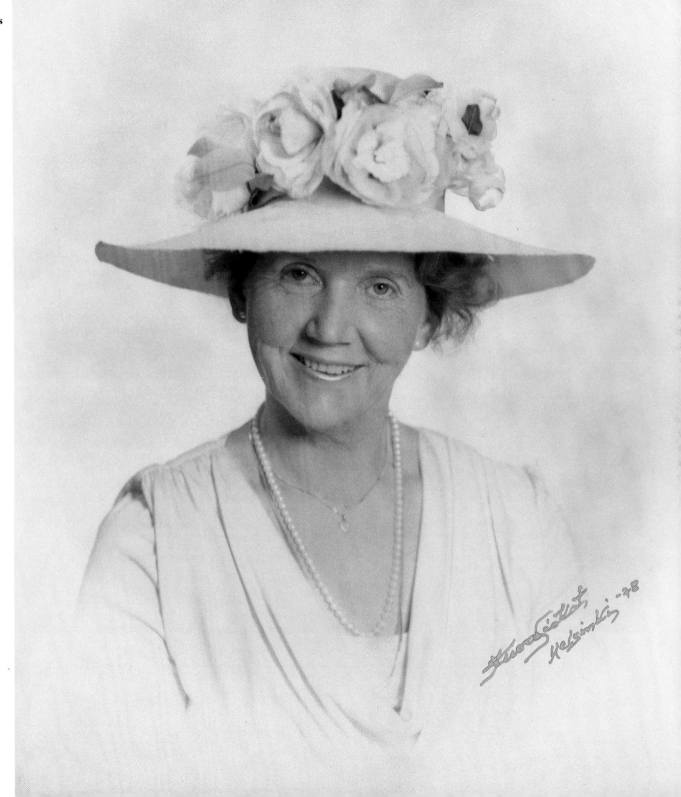

What Is Quality in Portraiture? This book is primarily a presentation of ideas for posing and lighting, but it is impossible to omit the mention of photographic quality in portraiture. A good photographic portrait is the sum of a number of different qualities: Lighting, composition, posing, your own individuality, and technical excellence are all parts of the whole. Each factor is important, but in this chapter we dwell on the subject of technical quality because its absence can reduce the effectiveness of all the others. Good technical quality makes the difference between a drab portrait and one that "lives"—conveys the personality of the subject, or tells the story you intended it to tell.

Technical Excellence

By technical quality we mean the delicate gradation in highlights, the muted range of colors and tones in deep shadows, the rich scale of hues and values between light and shade, as well as the contrast, density, and color balance appropriate to the subject.

Quality in a portrait is usually obvious only when it is poor. If it is very good, then the observer sees only the subject; he is not conscious of the technicalities of photography. This is as it should be. People are interested in the subject of the portrait, not in how the picture was obtained.

Art Versus Technique: There is no conflict here. Some photographers feel that because they have an artistic touch, they are absolved from the task of understanding the technicalities of the medium. This way of thinking is a mistake; you are only part-way to becoming an artist if you cannot use your tools to express yourself competently. The more you know about photographic materials and processes, the greater is your ability to use them to get the pictorial quality you want.

Negative Quality: No matter how imaginative or delicate your portrait lighting may be, it will not carry over into the print unless you pay attention to the factors in negative-making that influence image quality. These factors are (1) the camera lens, and (2) the choice of film, exposure, and development.

The Camera Lens: To avoid unnatural size relationships in pictures of people, choose a lens with a longer focal length than you would normally use. A focal length of about 1½ or 2 times the diagonal of the negative is about right for a head-and-shoulders portrait, while a somewhat shorter focal length is adequate for a ¾-length and full-length figures. The chart on page 20 gives suggested lens focal lengths and minimum working distances for various kinds of portraits taken in the studio.

Soft-Focus Lenses: Although the question of whether or not to use a soft-focus lens may be a matter of personal preference, most portraits are not made with sharp commercial lenses. Such lenses record every wrinkle, line, and blemish, and an inordinate amount of skillful retouching may be needed to make the picture presentable.

Soft-focus lenses are specially designed to leave a moderate residue of spherical aberration. The effect of such aberration is to image a point, not sharply as with an ordinary lens, but with a halo of decreasing intensity around it. The effect is to diffuse and reduce the contrast of the fine detail in the image as the highlights spread into the shadows. (Remember that putting the lens out of focus does not achieve this effect.)

With most soft-focus lenses, the amount of spherical aberration, and therefore the degree of softness, can be controlled either by stopping the lens down or by altering the separation between the component elements. If a soft-focus lens is not available, diffusing disks placed over the camera lens can be used to give a similar effect. Diffusing disks can also be used with an enlarging lens to achieve soft focus, but this method degrades the image as the shadow areas spread into the highlights and diffusers should be used in the darkroom only as a last resort.

Lens Care: Whether you use an old soft-focus lens or a modern, coated lens, it is essential to keep the glass surfaces clean. Dust, finger marks, and atmospheric grime cause an undesirable amount of flare, or non-image-forming light, to reach the film. (In addition, uncoated lenses may produce objectionable color fringing in color materials.) As a result, fine shadow detail is masked by fog and the contrast of highlight detail is lowered, sometimes to the point where it is nonexistent. Take care of your camera lenses and keep them covered when not in actual use. Constant cleaning with tissue or anything else eventually takes the high polish from the glass. Prevention is better than cure in this case, but when you *must* clean a dirty lens, use materials made expressly for the purpose and use them with great care.

Incorrect exposure of the negative is probably one of the main causes of poor quality in portrait photography. Too little exposure results in loss of shadow detail. In the case of black-and-white, the loss persists in spite of increased development. A print from such a negative will almost certainly have shadow areas that are just plain black patches without detail to relieve them. A print from an underexposed color negative will not only be without detail in the shadows, but the shadows themselves might have a bias in the blue-green direction that cannot be corrected in printing. Since the eye rarely sees shadows lacking detail in a scene, they are objectionable in reproduction. Even dark, low-key prints need detail in the shadows.

Negative Exposure

Correct Exposure and Exposure Latitude

Film Speed

Overexposure, on the other hand, produces several undesirable effects. The principal ones are a flattening, or a lack of gradation, in the highlights, and a desaturation of color. The effect of overexposing the negative shows in the print as a single tone instead of gradation in the highlights. This is probably the most serious of all shortcomings in portrait photography. No matter how good your lighting is, overexposure destroys its effect, and your prints are drab and lifeless.

Correct Exposure and Exposure Latitude: The question is how to get correct exposure. Before answering it, a few words about exposure latitude are necessary. It has often been said that the exposure latitude of black-and-white films, and to a lesser extent of color negative films, is so great that you can vary exposure by several stops and still get a good negative. This statement is not quite correct. Since film speed numbers are based on the minimum exposure necessary to yield adequate shadow detail, there is less tolerance to underexposure. If you overexpose a subject with a high brightness range, the highlights may be recorded on the shoulder of the characteristic curve; as a result, they will be flat or some of the detail will be lost. Remember also that the high density resulting from overexposure usually increases graininess in the negative and reduces color saturation in the color print.

Film Speed: Film speed numbers, or exposure indexes, are related to the exposure needed to obtain a specified density at some point on the characteristic curve of the film. A film speed number, however, does not stand alone outside the context of your particular photographic system. Any significant factor in the system can potentially alter the speed number that is correct for you. Consequently, it is a good idea to check your black-and-white exposure and development combination by making a ring-around as described in the Data Book No. F-5, *KODAK Professional Black-and-White Films.*

The film speeds of Kodak color negative films require a fixed development time-and-temperature combination. However, an added variable is introduced into the photographic system by the color temperature of the light source. Individual color film types are designed to be used with light of a specific color temperature and must be filtered if the color temperature is varied. This, of course, changes the recommended exposure index. When possible, make test exposures and prints. See Kodak Data Book No. E-66, *Printing Color Negatives*, for a complete discussion of the color negative-positive system.

Consistent use of a proper light ratio will permit photographers to take proper advantage of the "exposure latitude" that is inherent in current color negative emulsions. Well-illuminated portraits increase customer acceptance due to the flattering quality of the lighting, better color quality, and generally pleasing results.

Light Ratio: The intensity difference between two lights illuminating a subject — in terms of the total effect produced.

This is usually expressed in terms of a numerical ratio. As an example, a 3:1 ratio indicates that the subject side receiving the total effect of both lights is three times brighter than the side receiving only one light. This could be expressed in measurable units as well. An example: the highlight side would have 300 footcandles and the shadow side 100 footcandles. The expression "3:1" does not mean a 3:1 *f*-stop range, as will be pointed out later.

Normally, the two lights that are referred to by light ratio are the fill and the main.

Fill Light: The fill light is a source of illumination usually placed on or near the camera axis to provide total overall illumination for the subject. Its purpose is to permit proper exposure for shadow detail.

Alone, a fill light would provide rather lackluster lighting, since lighting that comes from the camera axis does not reveal the flattering contours or modeling of a dimensional subject. Since it is not the light that will create important highlights, many photographers use a relatively softer, or more diffuse source for this purpose. Soft white umbrellas, sky-lighter units, or large diffused

Lighting Ratios

lights are frequently employed as fill lights.

Main Light: This is the dominant light of the setting, referred to as the "key light" or the "modeling light." All terms are correct since the main light truly determines the "key" (high or low) of the scene, and its position produces the modeling contours of highlight and shadow. Relatively speaking, "harsher" light sources are chosen as main lights, when compared with the softer sources selected for fill light purposes. Direct parabolic reflectors, smaller silver umbrellas, and lights that will produce sparkling highlights are selected as main lights.

Ratio Numbers: A confusing element regarding light ratios stems from the numbers used to describe them.

Remember the main light only illuminates the highlight or brighter dimensions of the subject. It does not illuminate the shadow pockets that it creates.

Remember that the fill light, when placed on the camera axis, illuminates everything that the camera sees, meaning the highlight side as well as the shadow side.

A light ratio is expressed numerically, in terms of the total amount of light falling upon the highlight side, relative to the shadow side. The highlights receive the total effect of both main and fill lights: the shadows receive only the light from the fill.

Establishing correct light ratios can often be a simpler task with an understanding of the inverse square law.

Question: If a given light delivers 100 footcandles of illumination at a distance of 10 feet, how many footcandles would it deliver at a distance of 20 feet?

Answer: If you answered assuming that twice

Y. Kobayashi

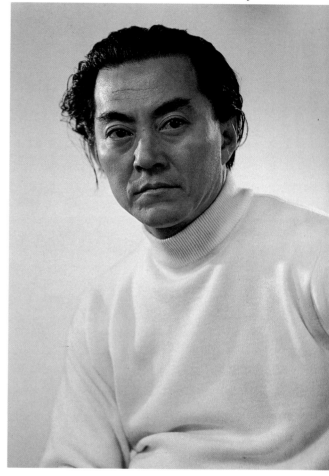

A high key portrait does not necessarily have to be soft and effeminate. In this "Portrait of an Artist," strength of character dominates the pure white background and costume. The classic lighting does much to reinforce the strength of the face by sharply delineating the planes of the features. Notice that the main light is far to the left background in the usual position for a product photograph — the classic narrow-lighting position.

Henk Gerritsen

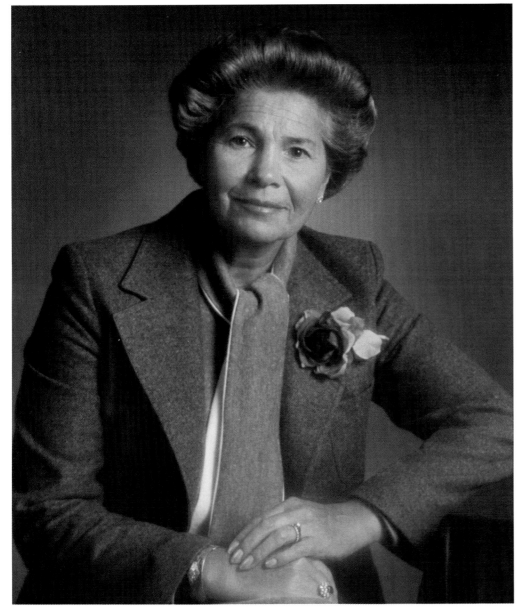

Lady in Gray: Two lights were used to expose this fine portrait, plus a reflector to fill the shadows. The main light was diffused with a translucent screen; the background light was concentrated on a spot on the wall below the subject's shoulders.
This photograph corresponds to the example of a 9:1 reflectance range referred to on page 15.
A Hasselblad camera equipped with a 150 mm lens and a Softar No. 1 filter was used.

the distance means half the light — 50 footcandles — perhaps the inverse square law should be reviewed. You were wrong! The inverse square law, which all lights are somewhat subject to, dictates that light energy falls off (inversely so) based on the square of the distance changed.

Squaring means multiplying a number by itself. Let us start with a light at 1 foot from the subject. Describe this light as being 1 times 1 equals 1 — inverting it makes it 1 over 1 or 1 divided by 1 of the light units emitted. Move the light back to 2 feet. Apply the formula, 2 times 2 equals 4, inverting it makes it 1 over 4 or ¼ of the light emitted. Move it back to 3 feet. Three times 3 equals 9 — 1/9 of the light emitted. Go back to the question above. Apply the formula — multiply the distance by itself, invert it to a fraction — and you have determined the relative light outputs. At 10 feet the light delivers 1/100 of its light, and at 20 feet it only delivers 1/400 of its light. That means that ¼ of the light is delivered to each square inch of the subject when you double the distance.

f-Stops and Distances: Many photographers have discovered that the inverse square rule is related to those all-important numbers, the *f*-stops. Since *f*-stops are something that are usually committed to memory, the relationship can be important. Consider the following: By testing, one could discover that if a light placed at 4 feet from the subject had produced 100 units of light, and you moved it to 5.6 feet, you would get 50 units of light — and if it were moved to 8 feet, you would get 25 units of light. Is something sounding familiar? The numbers used for *f*-stops, when converted to distances, can give one an insight into the inverse square law. You can convert the *f*-stop numbers into any

Lighting Ratios

distance-measuring units, and determine the relative output of a light at those distances.

Consider the following: If a particular light produced 100 units of illumination at 4 feet, here is the falloff rate at other "f-stop" distances — 4 feet equals 100 units, 5.6 feet equals 50 units, 8 feet equals 25 units, 11 feet equals 12.5 units, 16 feet equals 6.25 units. To test your knowledge of this principle — how many light units would the above light deliver at 2 feet? How many at 22 feet?

You can use feet, metres, inches, or any other distance unit to determine the inverse falloff effect of a light.

How to Produce and Calculate Light Ratios: For this exercise, let us start with the assumption that you have two lights that are exactly identical in light output and light quality.

Example No 1: With the main light at 4 feet, and the fill light at 5.6 feet, what is the resulting ratio? *Answer:* The main light is closer, and is delivering 1 stop more light, twice as much light as the fill light.

The shadows are receiving one unit of light from the fill light, and the highlights are receiving one unit from the fill light. The highlights also receive two units from the main light. The ratio? Highlights equal 2 from the main, 1 from the fill; total equals 3 units of light. Shadows equal 1 from the fill. The ratio is 3:1.

Example No. 2: The main light is at 4 feet, and the fill at 8 feet, what is the ratio?

Just as $f/4$ delivers 4 times as much light as $f/8$, the light at 4 feet is 4 times the intensity of the light at 8 feet. One unit of light for both the shadows and the highlights — 4 units of

light to the highlight. The result, a 5:1 light ratio. And that is how light ratios are created.

Scene Reflectance Range: Perhaps this is a new term to some. It is, however, very important when one is considering light ratios. Inherently, every scene or subject has a reflectance range. Consider this example: A bride, wearing a white dress that reflects 90 percent of the light, and a groom wearing a black suit that reflects only 10 percent of the light, represent a 9:1 scene reflectance range when both appear in the same photograph.

Another example: A blue-eyed blond, with pale skin, wearing a light pink dress might represent a very low inherent reflectance range. The brightest part of this subject (perhaps her pale skin) might reflect 60 percent of the light, while the darkest part (perhaps her dress) might reflect 30 percent of the light. In this case, she provides only a 2:1 reflectance range. If one were to make photographs with only the fill light, or perhaps, with only a simple flash unit affixed to the camera, the film would be recording the actual subject reflectance range and present a very flat photograph.

Brightness Recording Range of Film: What is the maximum subject brightness range that a film can record? What range can the total system reproduce?

These are all-important questions to the photographer who desires highest quality results, with all important shadow detail revealed and sparkling, detailed highlights.

Testing with color negative films would indicate that the films can record separation in detail with scenes that exceed a 150:1 brightness range. The films show a remarkable latitude in this respect. However, the

color paper is the true limit to the system.

Color paper, as used for prints from color negatives, is limited to its whitest white and its blackest black in determining what scene range can be reproduced. Measuring the density range of the paper, from a detailed highlight to a detailed shadow, indicates the limits of the system. This is generally determined to be a 40:1 range. The blackest black reflects only 1/40 of the light reflected by the whitest white. Thus, the photographer's palette is limited.

And what of color transparency methods?

Testing would reveal that most color transparency films cannot record or reproduce a range that exceeds this same magical 40:1 scene brightness.

Likewise, a properly processed black-and-white negative might record as much as 200:1 range in the original scene — but the paper that produces the final print can only reproduce about a 40:1 portion of the original scene. Of course, this can be expanded or contracted in black-and-white work by choice of paper contrast grade and altering developing times. By selection, one can expand or contract the range — with some definite loss in the in-between tonal separations in the scene.

Some elements that qualify the above statements: lens flare factors, background brightness ranges, optical glare, and variations in a film process can change the resulting range of reproduction.

Total Scene Brightness Range: The camera and film record the total scene brightness range, or the film makes an attempt to do so.

The total scene brightness range is the sum total of the light ratio combined with the scene reflectance range.

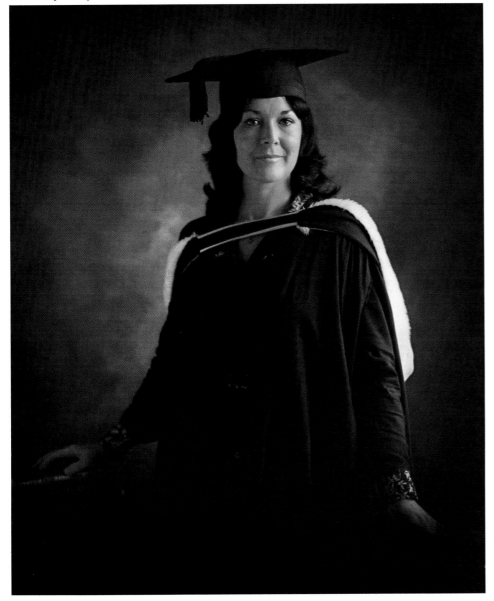

Anthony Henry

The light ratio multiplies the scene reflectance range. Here is an example—

Subject: A woman wearing a white lace blouse and a dark gray jumper top. The brightest portion of the scene, her blouse, reflects 90 percent of the light striking it. Her gray jumper reflects only 10 percent of the light striking it. The inherent reflectance range is 9:1.

Goal: Obtain a print with detailed sparkling highlights in the blouse, and revealing detail even in the shadows of the jumper.

Formula: Light ratio × subject range = total scene brightness range.

Assuming a 4:1 light ratio is used, here is what happens: Light ratio 4:1 × reflectance range 9:1 = 36:1.

A 4:1 lighting ratio with a 9:1 subject expands the total scene brightness range to 36:1.

Since 36:1 will easily record on the film—and will just barely reproduce on the color paper—you're safe!

Consider, in the above example, how the brightness range was reproduced. The brightest part of the scene was where both the fill light and the main light were reflecting off of the white blouse. The darkest part of the scene was where only the fill light was illuminating a shadow pocket in the gray jumper. Highlight areas were receiving four times as much light as the shadow areas. Four times 9 equals 36. One times 1 equals 1. The light ratio expanded the contrast of the original subject—and that is what it is all about. Effective use of proper light ratios can serve to expand or contract the subject's inherent brightness range.

The Graduate: A predominately low-key portrait study that is relieved by the white mantle. This is a studio shot without benefit of artificial illumination. Two reflectors, one on each side of the camera, return window light from the right rear to add fill illumination. The Hasselblad camera was set at 1/30 sec at *f*/4.

The KODAK Light-Ratio Calculator

The KODAK Light-Ratio Calculator is a slide rule designed to assist photographers who are setting up a portrait lighting arrangement. It is particularly valuable when the electronic flash units comprising the main light and the fill light are of different types or from different manufacturers. Since the units will probably vary in their respective outputs and might vary in the output of their modeling lamps as well, it is important that you review the manufacturer's data sheets to determine the proper guide numbers for each unit relative to the film you are using in the camera. If the manufacturer has not supplied the guide-number information, but has provided information concerning the beam candle-power seconds (BCPS) or the effective candlepower seconds (ECPS) rating for the unit, you can refer to the data sheet for the film you are using to find the appropriate guide number. (Watt-second input is not related closely to light output.)

The KODAK Light-Ratio Calculator will establish proper light ratios for average portrait-taking conditions with proper studio lights. Use the information to make tests with KODAK Light-Ratio Reflectance Cards to determine exact light unit placement.

When using the calculator, start with the fill-light side. Determine a working distance for the fill light that is appropriate for the *f*-stop required relative to the light output of the unit being used. Set that distance in line with the light ratio desired. Turn the calculator over; the proper distance for your main light will register in line with the guide number proper for your main-light unit.

The KODAK Light-Ratio Reflectance Cards

Use the Right Materials

A Word to the Wise

The KODAK Light-Ratio Reflectance Cards

Of course, you can use light meters, both reflectance and incident type, to measure light ratio if you are using tungsten illumination or if your electronic flash units have "ratioed output" modeling lamps. (If the flash units cannot be ratioed to their modeling lamps, you must use an electronic flash meter to determine intensity.)

To use a reflectance-type meter, determine first the output of the fill light alone by using a KODAK Neutral Test Card, 18 percent reflectance side at the subject (positioned facing the camera). Next, read the 18-percent reflectance side of the card while it is illuminated by both the fill light and the main light. Record the difference between the two readings. The lighting ratio is found by dividing the main light output plus the fill light output by fill light output alone.

To use an incident-type meter, stand at the subject position with the meter aimed at the camera lens. First read the fill light alone; then add the main light.

Another method of determining light ratios without the use of electronic instruments or any mechanical aid is to use the KODAK Light-Ratio Reflectance Cards. Because the human eye is a marvelously efficient comparator of density, as well as color, you can, with very little experience, obtain a desired lighting ratio to a very small margin of error by using these varied-density gray cards. You can select any one of four different ratios: 3:1 for most portrait subjects, 2:1 for subjects with an inherently high contrast, 4:1 or 5:1 for subjects with inherently low contrast or when a higher-than-average contrast is desired for special effects.

To use the Light-Ratio Reflectance Cards of your chosen ratio, place the joined cards containing the numerical ratio you wish in the subject position at head height with a dark background and base, such as a focusing cloth, positioned behind and below the cards. Arrange the cards so that the darker section of the cards is on the main-light side and the lighter section is on the shadow or fill-light side of the subject. The lighter section should be illuminated only by the fill light. The darker section should be illuminated by both the main light and the fill light. Adjust the cards to eliminate any shiny surface reflections when viewed from the camera. Adjust the relative intensities of both lights, while viewing the cards from the camera position, until both card sections appear identical in brightness—that is, until both appear to be the same shade of gray. When you are satisfied that both sections appear identical, measure the distances from the lights to the subject and record the information. Reposition the lights a second time, as a check. After very little practice, you will be

Use this side first

1 The Fill Light

Select the desired light ratio.
Select a working distance
proper to the f-stop required.

2:1 ratio

400	10'
340	9'
280	8'
240	7'
200	6'
170	5½'
140	5'
120	4½'
100	4'
85	3½'
70	38"
60	32"
50	

3:1 ratio

400	14'
340	12½'
280	11'
240	10'
200	9'
170	8'
140	7'
120	6'
100	5½'
85	5'
70	4½'
60	4'
50	3½'

5:1 ratio

400	20'
340	18'
280	16'
240	14'
200	12½'
170	11'
140	10'
120	9'
100	8'
85	7'
70	6'
60	5½'

Light Ratio Calculator

Use other side first

2 The Main Light

Once you've made your choice
and setting for the Fill light
on side #1, place the Main light
at the distances shown below ...

400	10'
340	9'
280	8'
240	7'
200	6'
170	5½'
140	5'
120	4½'
100	4'
85	3½'
70	38"
60	32"

able to consistently establish proper lighting ratios without error.

Since the KODAK Light-Ratio Reflectance Cards are visual tools, it is not necessary to include them in the scene when making an exposure. However, when you first use the cards, making a photograph that includes them will provide confirmation of the ratio of fill light to main light, and also prove the validity of the output of the modeling lamps.

Turn off all other ambient room lights while making adjustments.

When using the KODAK Light-Ratio Reflectance Cards with electronic flash, be sure that the modeling lamps are of the "ratioed-output" type. This means that the visual output of the modeling lights matches a standard percentage of the actual output of the flash tube for both lights in use. Lights of different manufacturers require special testing to determine if the percent of modeling light to flash tube output is the same in each of the units.

Use the Right Materials

There is a great deal of variety in both black-and-white and color film and paper products. It is therefore important to choose those that give the results you are seeking. Although many films and papers are versatile, generally one or two of them will be particularly suited to a given application. For information about choosing films and papers, see the Data Books No. F-5, *KODAK Professional Black-and-White Films*, No. G-1, *KODAK Black-and-White Photographic Papers*, and No. E-77, *KODAK Color Films*.

A Word to the Wise

Remember that anything at all that requires an artistic or a creative approach is subject to false starts, revised thinking, or a temporary deficiency of ideas. Never hesitate to say, "I don't like this result; I must do the job over again." If you do not like the picture, the chances are that other people will not like it either. You must be the judge, the jury—and the executioner; burn the print if it's not good enough. A poor photograph not only reflects directly upon its creator, but more importantly, lowers the status of the photographic industry as a whole.

Traditionally, formal portrait sittings have taken place only in the studio. The necessity for skylights, large incandescent lamps, high-voltage power supply, unwieldy stands, and other specialized equipment dictated a special place for making photographs. Modern films, cameras, and light sources make these requirements obsolete, but the portrait studio, if suitably arranged, still remains ideally suited to its original purpose.

Today, the portraits produced in professional studios still dominate the field, both in quality and (except for school pictures) in quantity. There is a definite trend toward location and outdoor portraiture, but the photographers who travel to outside sittings need a home base in which to experiment and perfect their skills. The laboratory that is the professional studio will continue to be the birthplace of portraiture that is both inventive and imaginative.

The Studio

It is a place away from distraction, where photographer and subject can be in harmony. It is a familiar place, comfortable to be in, with tested equipment that works without a flaw — a place where every possible variable in light and color is known and controlled; where the photographer, manipulating the lights, camera, and subject, can progress from pose to pose without interruption, where the sitter is subjected to no unnecessary noises or surprises, and composure and privacy can be maintained.

Because the portrait studio is still a special place, it should not be degraded. It is not a club room or a lunch room. Keep the production staff out! The smell of stale cigarette smoke and salami sandwiches or the sudden appearance of shadowy forms beyond the modeling lights is not conducive to rapport with the sitter. It is not a storage area. Keep spare lights, posing benches, furniture, cameras, and backgrounds in a convenient anteroom, ready to be brought forth when needed between sittings or while the subject is in the dressing room. Make sure that the pathway to the posing bench is not an obstacle course. Arrange the equipment so that light stands, tripod, and particularly electric power cables are safely out of the way. Make every effort to see that your customer has a completely pleasant experience in your studio and he will want to return.

Studio Size: The camera room should be spacious enough to move around in, with sufficient working space completely surrounding the posing bench.

An important dimension is the distance from the posing bench to the background. It should be enough so that no shadow from the

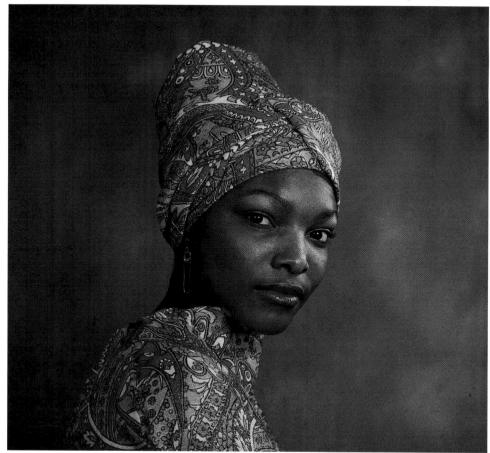

Jack Newsom

Studio
Portraiture

The Studio
Studio Size
Working
Distances

subject will fall on the background, no matter how tall the subject is. This distance should also allow the background to fall out of sharp focus when the lens is stopped down to the working aperture.

There should be foreground room enough to permit the use of a lens of fairly long focal length and still cover a half figure. And there should be plenty of room behind the camera to allow the photographer to move about freely and without hazard.

The width of the studio should be such that both the main and the fill lights can move in an arc around the subject to the background without forcing a change of the light-to-subject distances.

The floor space around the posing bench should be the most constantly used space in the studio. A portrait lighting setup should not be static; that is, it should not be one with the lights placed in set positions and unmoved from sitting to sitting. Move the main light and the fill lights back and forth, as well as up and down, to create patterns and ratios of highlight and shadow on the contours of the subject's face until the effect is most pleasing. It follows that, since no two subjects are alike, no two lighting situations should be exactly the same.

Working Distances: The following chart was compiled to give the minimum studio working space needed to take a particular kind of portrait. Note that with certain wide-field lenses this minimum camera-to-subject distance can cause some subject distortion at the edges of the picture.

Jack Newsom

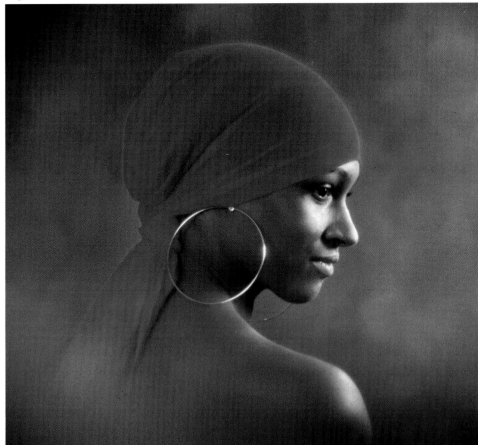

By changing only two units of the lighting arrangement, and going from a 3/4 face to a profile, see what a change in mood can be attained. But remember, the lights were changed; not allowed to remain stationary.

"The skylighter unit is an 800 watt-second electronic flash unit overhead and was 9 feet from the subject. It furnishes the overall illumination. The background light, at 25 watt-seconds, is diffused and for the portrait on page 18, was pointed down at about 45 degrees for separation of background and subject. The umbrella at 400 watt-seconds and 4 1/2 feet from the subject is to create the ratio of light and, of course, to contour the face. It was feathered slightly toward the camera. The parabolic reflector is raw at 100 watt-seconds and barn-doored to an opening of about 3 inches at a distance of 6 feet from the subject. It was tilted so as not to glare into the lens and to create spectral highlights on the lightest areas of the flesh. The background was 7 feet behind the subject and is painted in subdued browns, blues, and greens."

"This lighting is basically the same as the photograph on page 18. The exceptions are the background light, which was pointed directly toward the background and slightly up, and the umbrella and parabolic reflector, which were rotated toward the face. Each light is accomplishing the same illumination as in the previous description."

Studio Portraiture

The final dimension to consider in the portrait studio is the ceiling height. It should be high enough to clear the hair-light boom and provide vertical space for a background adequate for a standing figure.

Whatever its size and location, the portrait studio is, above all, a working place, productive and professional, containing everything needed to produce photographs that are technically and aesthetically worth the price of purchase.

Working Distances

Film Size	Type of Portrait	Suggested Focal Length*	Minimum Working Space† (in feet)
35 mm	Head and Shoulders	75 mm	16
	Full-Length Figure	50 mm	17
	Groups 10 Feet Wide	35 mm	17
2¼ x 2¼ inches	Head and Shoulders	120 mm	16
	Full-Length Figure	80 mm	18
	Groups 10 Feet Wide	50 mm	19
2¼ x 2¾ inches	Head and Shoulders	135 mm	16
	Full-Length Figure	90 mm	15
	Groups 10 Feet Wide	60 mm	18
4 x 5 inches	Head and Shoulders	8½″ to 10″	15
	Full-Length Figure	6″	16
	Groups 10 Feet Wide	100 mm (wide field)	18
5 x 7 inches	Head and Shoulders	12″ to 14″	15
	Full-Length Figure	8″ to 8½″	15
	Groups 10 Feet Wide	135 mm (wide field)	16
8 x 10 inches	Head and Shoulders	14″ to 16″	15
	Full-Length Figure	12″	17
	Groups 10 Feet Wide	190 mm (wide field)	18

*Not using camera swings.

†These values assume the image occupies 90 percent of the negative dimension and includes an allowance of about 7 feet for lights, background, and camera working room.

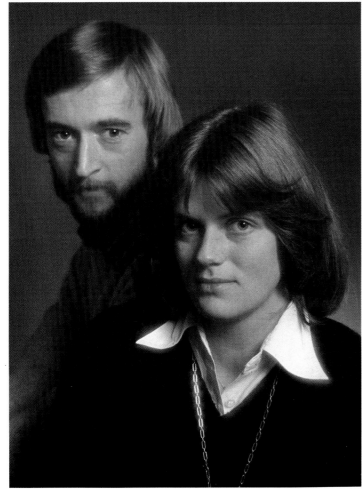

Sam Campanaro

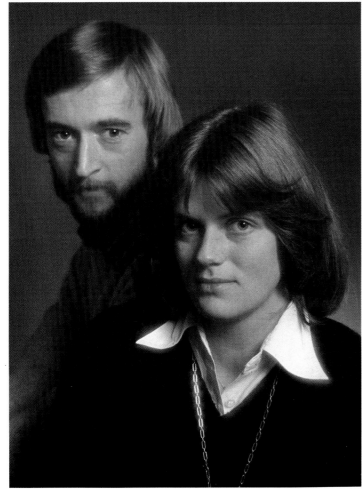

Note: The above refers to the oval family portrait on the right.

Henk Gerritsen

Brigitte and Martin: A simple and effective lighting technique consisting of a diffused main source on the right and a reflector as fill on the left, plus a spotlight on the background, makes a double portrait of a modern young couple most pleasing. The use of a Softar No. 1 diffusion filter over the lens reduces the necessity for retouching and adds a touch of softness that is not distracting.

"*I wanted to make a portrait of a family that could be used in our office decor. My assistant, Sally MacGowan, said she knew of an attractive black couple who had a twin son and daughter.*

"*My idea was to photograph them in an intimate mood. Although the portrait looks like they are in the nude, I assure you they are not. Mrs. Williams is wearing a backless halter top, the children are in underpants and Mr. Williams removed his shirt.*

"*Their skin tones were so pleasing I decided to use a black background to keep all the tones in brown and black. To achieve this, Sally even removed the red bows from the little girl's braids. The strong backlight was needed to give separation of subject to background. A soft key light was used along with a skylight fill. A black vignette was used at the bottom to blend with background.*

"*Of the many portraits hanging in our office, this one receives the most accolades. I knew I succeeded in making an outstanding portrait when my daughter Vickijo asked if she could have a 16 x 20 print to decorate her apartment. Her comment was, 'Daddy, you captured the love and warmth of that family, and it gives me a nice feeling.'*"

Studio Portraiture

"These photographs represent a fast-growing facet of my work — the discreet nude. The use of luxurious draperies and careful lighting combine to produce a result that is unlikely to cause embarrassment or offense. As with all my portraits, the lighting is arranged to appear natural. The warm tones are produced by a single golden parasol-reflector far to the side. The pictorial effect is as important as the fidelity of the portraits."

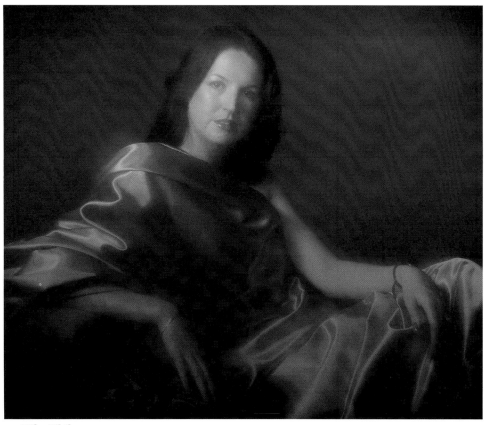

Mike Sibthrop

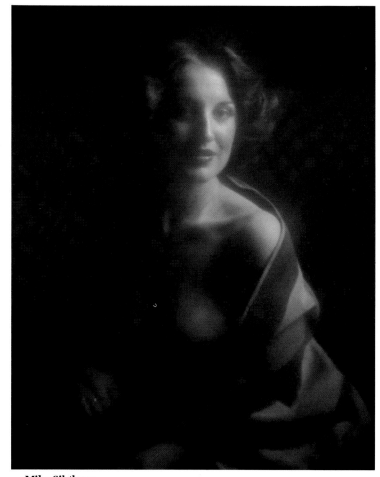

Mike Sibthrop

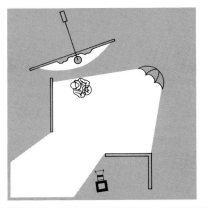

The Pastor: A transparent vignetter was used in front of the lens to destroy extra background and bring the viewer's attention to the subject. A textured wall flat performs as cathedral wall and a newel post as lectern. The lighting consists of one umbrella to the right, turned so that only the edge of the light strikes the subject, giving a spotlight effect, and another light on the top of the textured wall, adding more texture, with a reflector to the left and a white gobo protecting the camera from flare and adding front fill.

"This portrait was taken with a Mamiya RB-67 camera and a 180 mm lens. The lighting was a very simple two-umbrella setup, using Norman 125 watt-second electronic flash units. The key to the rim-lighting effect is to get the main-light umbrella far enough around behind the subject and use a scrim to shield the light from the lens. The fill light is just enough to break the figure from the background."

John Kasinger

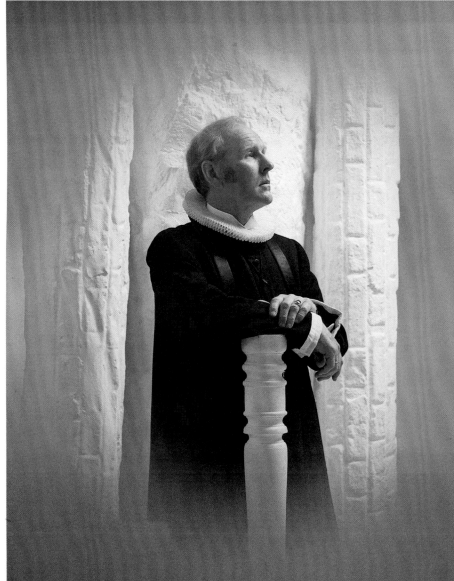

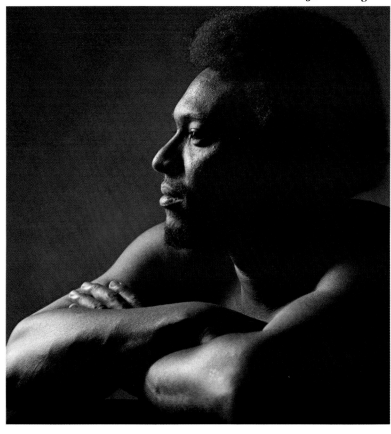

Peder Austrud

23

Studio Portraiture

The softness of window light alone, reflected by panels on both sides of the camera, illuminates this dignified portrait of a nursing sister.

Such natural-light portraits exact a toll in shutter speed and lens opening. Here exposure was 1/30 sec at f/2.8.

The Lavender Dress: This dignified portrait was made with several innovative photographic touches. A cellophane filter was used in front of the lens to act as a diffuser, and a strip of Scotch tape was added at the level of the hands for extra softening of the image. A Fresnel lens on a projector imaged the background. An umbrella for a main light on the left and a very diffused floodlight on the right completed the setup.

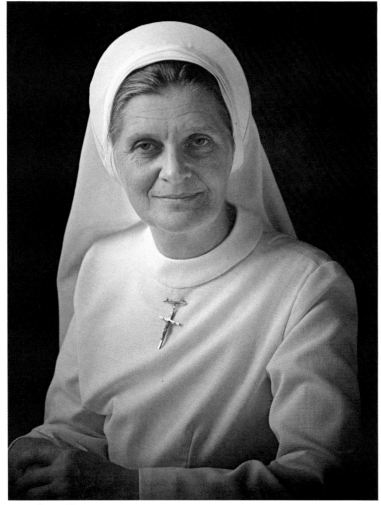

Anthony Henry

Gabriel Comtet

Ernie Curtis

Executive portraiture is one of the most important tools in the field of public relations. Good photographs of management people can help create a favorable public image for almost any corporation. A press release accompanied by a portrait of the individual involved stands a better chance of being picked up than one that doesn't. In fact, sometimes the picture can make or break the story. Color portraits, in the form of 35 mm transparencies, are valuable visuals to accompany news releases to local TV stations.

Portrait Photography in Industry

In another application, enlarged color portraits of leading executives can be used in a gallery that is strategically placed in a public area of the business office to create a corporate image of capable, dependable, and interested management. The executive gallery can be used to personalize board rooms, to impress and reassure customers in places of business, to make an exhibit at institutions the corporation has endowed, or to humanize the image of management in employee lounge areas. There are many other

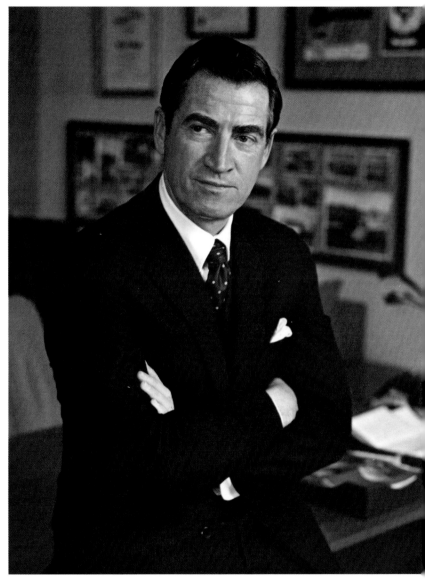

Since a 30 x 40-inch color print had been presold, a 5 x 7 camera, with a 10-inch lens stopped down to between $f/8$ and $f/11$, was employed to photograph this executive in his office. The subject was seated on the edge of his desk, about 10 feet from the background. Two 45-inch electronic flash equipped umbrellas of 200 watt-seconds each were the illumination. The fill light was 9 feet from the subject to the left and the main light was 5 feet to the right. There were no hair or background lights. The objects on the desk and back wall were rendered out of focus by the shallow depth of field at this f-stop.

Portrait Photography in Industry

uses for photographs of a company's executives, too—the personnel department, for instance, requires pictures of employees for records and the company magazine would like photographs to illustrate articles. Each executive can carry personal photo business cards that provide business contacts with ready identification. Stockholders reports are illustrated with pictures of top executives. The executive would probably welcome a color print of the portrait for personal use. And fellow workers might enjoy receiving a portrait upon retirement.

In many companies, the prime aim is to keep a file of fresh portraits by updating them periodically. As soon as an employee is elected to executive status, he is rushed to the portrait studio. At the sitting, both formal and informal poses, as well as pictures for the new executive's personal use, should be recorded. Both black-and-white and color films should be exposed (or provision for prints on KODAK PANALURE Paper should be available). Backgrounds and props should be simple and inconspicuous, but should reflect something of the executive's personality or specialty. Whether the portrait is done in the studio, as at night, or on location in the business office, as on page 25, the emphasis remains on the individual, with the surroundings subdued by lighting or selective focus. Updating sittings should be scheduled regularly. Retouching of negatives and prints should be minimal.

Executive portraiture is an interesting and challenging field. The professional portrait photographer who recognizes this need of industry, or the industrial photographer who takes on the tasks of company public-relations portraiture, will find the work well worth while.

"I usually adopt a light ratio of at least one to six for a man's portrait.

"In this case, I used a composition based on an equilateral triangle, regarding the man, chair, and other accessories as one subject. I am sure that the composition is good when the man's head is at the apex of the triangle. Of great importance is that the direction of the eyes creates a flow in the triangular composition. In this portrait, the vertical line separating the tones of the background is carefully placed through the center of the composition located at the exact center of the subject's head."

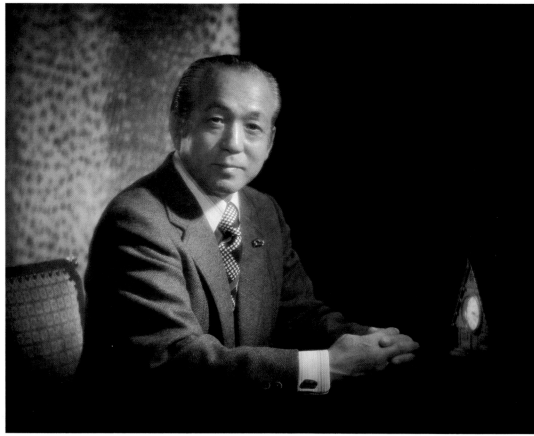

M. Takemori

Studio Portrait Backgrounds

Generally, you should strive for simplicity in the background. Not only does simplicity yield more artistic results by maintaining the accent on the sitter, but it is a practical fact that the repeated use of a background with a definite or easily recognizable design quickly dates your work. Probably the most widely used background is a large, flat, unmarked surface. This can be paper (such as a large roll of seamless background paper, 9 feet wide, suspended from the ceiling), a painted screen, or an actual wall of the studio. To help prevent distracting reflections or color casts, paint the screen or wall with matte rather than glossy paint. By varying the relative amounts of illumination on this background, you can easily control the overall tone, and you can introduce variations by throwing a shadow across an area of the background. You can produce simple back-

Theo Germann

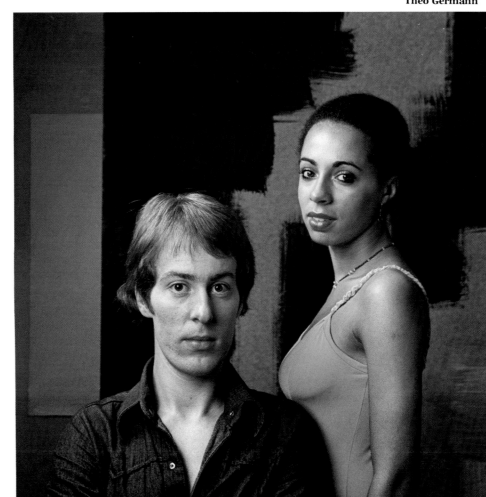

An abstractly painted series of background panels complements the angular pose of this couple. The lighting consisted of two umbrellas on the left — one directed at the subject, the other bounced from wall and ceiling.

27

Studio Portrait Backgrounds

grounds without difficulty. They can be made of a piece of lightweight muslin stretched on a frame of ample size and painted with flat latex paint. Incidentally, a posing platform about 8 inches high is an excellent aid in the portrait studio. It helps elevate the subject to a more convenient working height and also helps to eliminate the background floor line in ¾ portraits.

Give the color of the background careful consideration. Backgrounds having large masses of one bright color are usually not suitable because they have a tendency to overpower the color likeness of the subject. An effective background might employ a soft cloud effect in which the colors are quite subdued. Slightly warm-colored backgrounds are suitable for most subjects, especially for low-key portraits. In general, avoid cold-colored backgrounds because they may reflect from the sides of the face, giving a sickly look to the subject. Also, proper visual color balance is more difficult to achieve in printing a color portrait with a cold background because the complementary colors contrasting with warm flesh tones make the flesh appear excessively ruddy.

Painting a Studio Background: With a section of canvas, some paint, and no artistic training whatsoever, you can create a portrait background that will result in photographs that are personal and distinctive.

You will need canvas from an awning store. The size will depend upon your studio space. If there is plenty of space, you can find excellent use for a 12 x 12-foot canvas. This is suitable for full-length, large ¾, or family-group portraits. An 8 x 8-foot canvas can

handle these categories, too, though with a group limit of three. For these sizes, mount the canvas on a simple frame of 2 x 2's, and tack it into place. Add a set of rollers for easy mobility.

In the sizes mentioned above, you may find there are seams. However, with the subject standing 5 or 6 feet in front of the background and with the lens of a 4 x 5 camera set at $f/8$ to $f/11$, seams do not show. The seam could be a problem in a smaller studio where

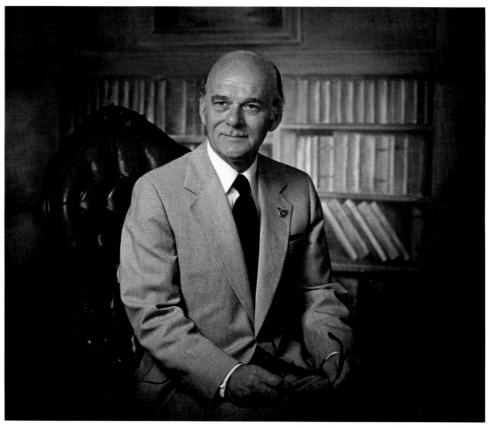

A painted background, which is different from the ordinary, sets this executive portrait away from most. The pale monochrome of the background and the matching color of the subject's suit force attention to his face. The tufted, red leather chair acts as a color foil to the composition.

John W. Venus, Rembrandt Studios

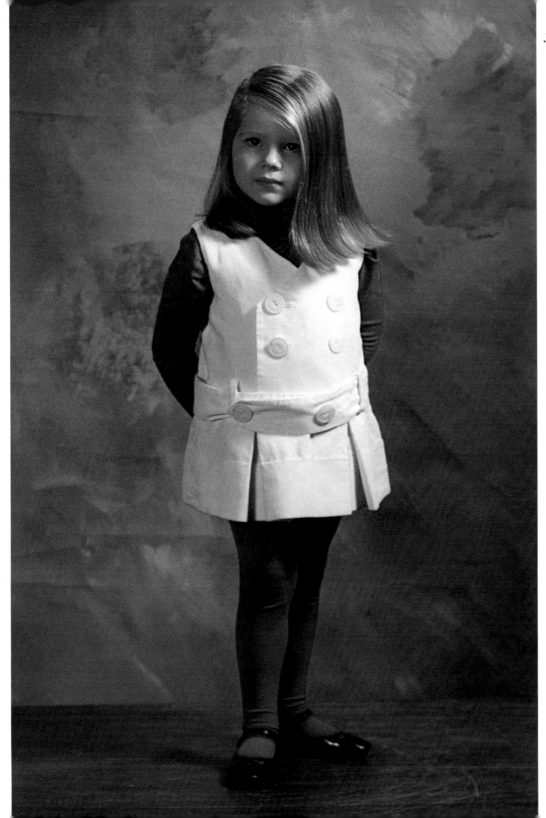

space does not permit this separation between subject and background—and here a window-shade-size canvas, suitably equipped to let you roll it up for storage, would be preferable.

You will need either water-based or oil-based colors for your background: water-based for a high-key (pale) background, and good semimatte oil based for the dark low-key variety. Any reflections can be eliminated by applying an overcoat of flat varnish or by blending an additive with the paint to remove gloss.

Your painting instruments are a roller, brush, sponge, and cloth. The roller and brush produce the harder lines and distinct patterns. Sponges and cloths are employed to blend the design together, removing harsh contrast and providing a swirling "oil painting" look.

For low-key backgrounds, pick the earthen tones—brown hues with additions of white, green, black, or red as required. Such backgrounds are good settings for adults, and for the more formal type of child and teen portraits. The high-key backgrounds are most effective for children in general and for fashion illustrations. Judge the finished background by viewing it through the ground

Studio portraiture in the traditional style has not gone from the world of fine color portraiture.

The studio camera was equipped with a 12-inch KODAK Commercial EKTAR Lens. Two 20-inch Photogenic Studio Master electronic flash units fitted with barn doors provided the illumination. The main light, to the right, was without a diffuser; the fill light, at the camera, was covered with a spun-glass screen. The film was 4 x 5-inch KODAK EKTACOLOR Professional Film.

Studio Portrait Backgrounds

Family Portraiture in the Traditional Style: A spotlight projects the shadow of a ship's wheel on the background in this portrait of a nautical family. A single umbrella far to the right background is the sole illumination. Fill light comes from white studio walls. The single light source was prevented from flaring the 150 mm lens by means of a gobo. Simple props complete the composition.

Peder Austrud

glass with the camera focused on the spot where the subject will be and with the lens at the *f*-stop that will be used.

How many backgrounds should you have? Literally as many as you can manage. The greater the variety of painted portrait settings available, the more versatile your service. You can find the right background for every subject, including the couple who arrive clad in unexpected hues, or the brunette who became a blond between appointment and sitting. Three backgrounds — one high-key, two low-key — would be an excellent starting set. At an average cost of $30 — plus paint, frame, and rollers — it is a modest investment.

Because it will increase your versatility, enrich your composition, and cut down on printing cost, you'll find the painted background a simple and serviceable addition to your studio.

Background Lighting: For the photograph to retain the same background color as you observe visually, the background must receive the same amount of illumination as the subject's face. For example, if the main light is 4 feet from the face, a light of equal intensity must be placed 4 feet from and turned toward the background. Position the subject 5 or 6 feet from the background in order to prevent spill from the main light from affecting the background tone and color saturation. Do not rely on spill light to illuminate

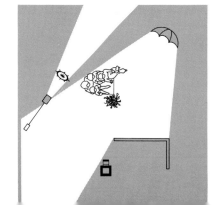

the background; it should be treated as a separate subject. Light it independently.

Two other excellent reasons for placing the subject at least 5 or 6 feet from the background are to prevent the background color from reflecting onto the subject and to allow background detail to go out of focus.

Background Lighting for High-Key Portraits: White backgrounds for high-key portraits can be very effective, and you can produce them easily by using on the background a light of sufficient intensity to yield a background brightness four times that of the main subject — usually about the same total amount of light used for the subject. (A reading with a reflection light meter should read 2 stops brighter than the subject.) Employing the same white background and reducing the strength of the background light to that of the main light is apt to produce greenish or bluish-grey tones around the subject in the falloff areas of the background.

In using white backgrounds for high-key portraits, there is considerable danger that excessive flare may cause a loss of picture contrast. To minimize this problem, photograph the background at a slight angle and make sure that the background is no larger than necessary. Use an efficient lens hood and black screens, just out of camera range, to minimize this image-destroying flare.

The Umbrella — A Portable Skylight

One of the greatest innovations in portrait photography in recent years is the soft lighting technique produced by the use of umbrellas. The photographic umbrella is remarkably similar to the "bumbershoot" used to protect the upper portion of a pedestrian from the elements; it consists of a metal shaft

and a collapsible framework covered with cloth. Only the cloth covering differs. It is made of white or silvered material that is highly reflective. The light source—electronic flash, tungsten, or quartz lamp—is mounted on the shaft and aimed at the center of the underside of the parabolic framework. The quality of the light that is reflected from this surface is reminiscent of the soft, diffused, nondirectional light produced by the north skylight of early photographic studios. Here is a broad, natural-looking light source that is extremely portable.

The quality of skylight illumination varied from the soft dullness of a cloudy day to the relative sparkle of the sunny, clear sky that produced definite shadows, even with the light from the north. So, too, the quality of the umbrella light can be changed to match the mood of the subject. Umbrellas are available in a variety of shapes, sizes, and reflective qualities: 3 to 6 feet in size, square or round, flat or parabolic, matte or smooth, white or silvered. By changing the shape, reflective surface, or manner of mounting the light source, you can obtain a series of increasing contrast.

• The softest umbrella illumination is produced by a flat matte-white surface, with the light directed entirely toward the reflecting surface from as far down the umbrella shaft as possible.

• You can achieve slightly more direction or contrast with a silvered, still flat, umbrella.

• More sparkle is added if the umbrella is a silver parabolic canopy, with the light directed into it from the focal point on the umbrella shaft.

• Still additional specularity can be created by using a bare bulb in the silver parabolic canopy. The effect here is toward a point source, softened by the additional light reflected from the canopy.

Fill light is usually from another, more diffuse umbrella or from a flat reflector.

Yasutaka Kajiyama

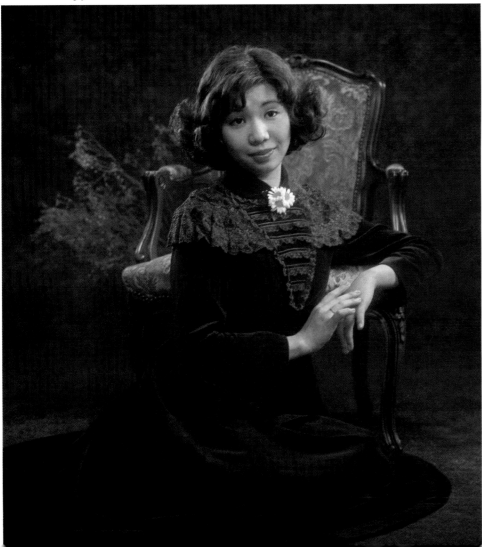

"This young lady, who is soon to be 20 years of age, gave to me the impression of calm beauty. I selected a chair and background to match her classic costume. Most of the background cloth, which had been purchased ready-made, was repainted to be harmonious in color and tone.

"I placed a diffusion filter in front of the lens to produce a very slightly soft effect and caught this enchanting image."



not to mention the details of knowing how to operate a cumbersome camera. On top of all the techniques, a true professional had to have a sense of artistry.

Today, the burden of having to know the techniques of processing and printing film has been made so simple that anyone who wishes to develop his film can do so with considerable ease. The biggest change in photography has been the advent of processing laboratories which have freed the photographer from having to do anything but take the picture. Nowadays, anyone can take reasonably good candid pictures with virtually no prior experience. Have the professionals seen their day? Are they relics of the past, no longer needed? Have they been automated out of business? Not at all! The professional wedding photographer is alive and well, in fact doing better than ever. "Why is that?" you may ask, "with all that army of candid snappers at every wedding." The answer is really quite simple, but first let's look back at photography's history.

Early wedding photographers used cumbersome cameras which had very little mobility. Wedding couples had to go to the studios to have their portraits made. When the camera was taken out on location, it was for the purpose of capturing the great big

A classic bridal portrait with a traditional and beautiful background. The single electronic flash unit that was the main source of illumination was balanced by daylight coming through windows between the columns on the right. The direction of the natural light was from the back of the church and provided the strong illumination for the huge stained-glass window.

Notice that details, such as the placement of hymnals and the cleanliness of the aisle, have not been neglected and that the rules outlined in the text have been followed scrupulously.

Rocky Gunn

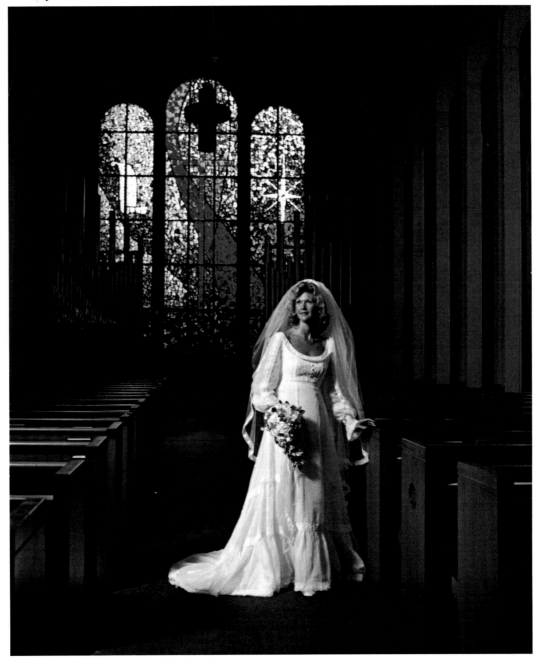

33

Wedding Portraiture, Today and Tomorrow

A dramatic location and an appropriate pose make a beautiful illustration.

This is a self-portrait, taken on the photographer's honeymoon in Scotland. Such backgrounds are in existence, and if one is nearby it should be treasured.

The colors of the background have been enhanced in retouching.

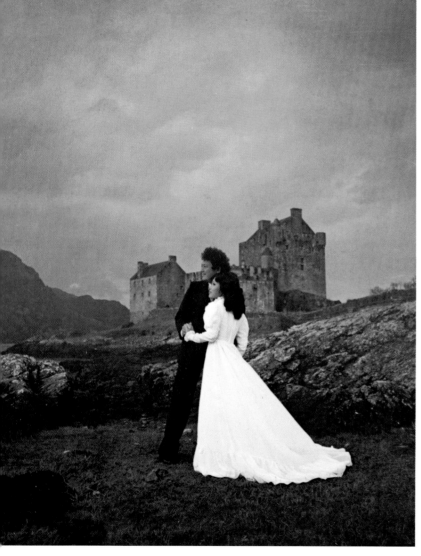

Rocky Gunn

group picture of the entire wedding party.

The 4 x 5 Speed Graphic of the 1930s became a trademark for professional photographers. With flashbulbs and film packs, the professional photographers were able to travel to the events and capture the action. "Candid photography" became a household phrase and finally became as popular as the familiar studio portrait. There became a division between the portrait photographer and the candid photographer.

The portrait photographer cared about creating photographs of exquisite beauty. The purpose was to photograph a bride and a bride and groom so that they could have a portrait of "timeless" elegance — a portrait that would look beautiful through the years and would be passed on from generation to generation.

The candid photographer was concerned with capturing the action of the event, telling the story of the day. Photojournalism became the technique that most candid photographers leaned towards. Through the years, the division of the portrait photographer and the candid photographer grew until two completely different schools of thought came to be. Candid photography became the accepted universal standard. Portrait bridal photography was an art form that few photographers learned. Gradually the portrait masters became fewer and fewer.

The advent of new equipment made the taking of pictures relatively easy. Since anyone was able to take reasonably good candids and the emergence of a romantic tradition began to grow, wedding photographers knew that they had to change. The majority of professional wedding photographers are self-taught and learned from on-the-job training through the years. The majority of them were, without question, basically photojournalists. Very few of the wedding professionals had the advantage of learning their craft under the tutelage of an accomplished bridal portrait master — there were very few of the bridal masters left.

In recent years, the emergence of teaching seminars has brought education and knowledge to every profession much quicker than any artisan-master trade system ever did. In the field of professional wedding photography, photographers are able to get firsthand instructions on the techniques of true portrait lighting and posing from the few remaining masters of portraiture.

Today the modern professional wedding photographer is a person who can capture the excitement and emotions of the wedding day with photojournalistic methods and at the same time create the classic beauty and elegance of the master portrait.

It is my personal opinion that the modern professional wedding photographer must be able to deliver three styles of photography. The three factors that most brides want are:

- *Realism* — to capture the emotions and excitement of the day is what most brides ask.

- *Tradition* — the ability to take the traditional pictures is what prominently separates the professional from the amateur. Telling the story of the day and at the same time creating beautiful portraits is the mark of the professional wedding photographer.

- *Illustration* — the ability to insert the look of today's influence of television, records, greeting cards, and movies is growing in popularity. More and more of the mood and art look will find its way into the wedding albums of modern couples.

The professional wedding photographer is

Monte Zucker

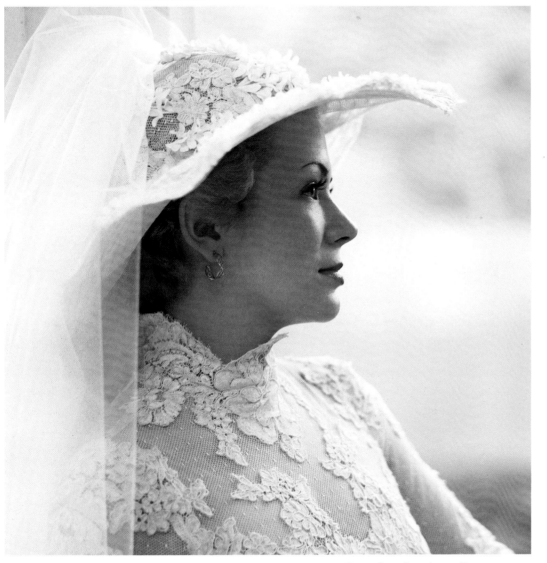

"The bride was standing on the edge of a small round gazebo. The profile lighting was by natural light and the background is fall-colored leaves, several hundred feet behind the subject, lit by a late afternoon sun just before sunset.

"Made with a Rolleiflex SL66 camera with a 150 mm lens and a soft-focus filter."

able to deliver a series of photographs that encompasses all the three basic wants of the brides. And they do it without turning the bride's day into a picture-taking session. That is why the professional wedding photographer survives today.

The purpose of this article is to explain the portrait view of a wedding bridal. In the old days, it was the purpose of many portrait people to show the bride in her dress with the idea of creating an image that blended the dress and the girl into an elegant photograph that would represent an idea. The portrait was to represent the tradition of marriage.

The bride and her gown were posed and fitted in such a way so as to project the idea of heirloom tradition, classic elegance, and timeless beauty. To accomplish these goals, most of the master wedding portraitists relied on certain basic principles.

One of the main reasons that certain poses were used was that most brides looked more graceful and lovely when in these poses. These poses, themselves, became known as the classic poses which by definition, are a universally accepted technique of presenting a form of the body. The proper form will retain geometrically pleasing lines and will give the appearance of stately elegance, calm grandure, and universal appeal. From these classic poses and forms came the terms "the timeless beauty of a bridal portrait."

Let us examine one of the basic poses: The first thing of importance to a full-length pose is the foundation, which starts with the feet. From the feet, the body can adjust to one of several basic forms. Once the body is in balance, the hands and arms can be formed and finally the head positioned. For the basic stance of either a bride or groom, advance one foot and shift the weight to the back hip.

Wedding Portraiture, Today and Tomorrow

Monte Zucker

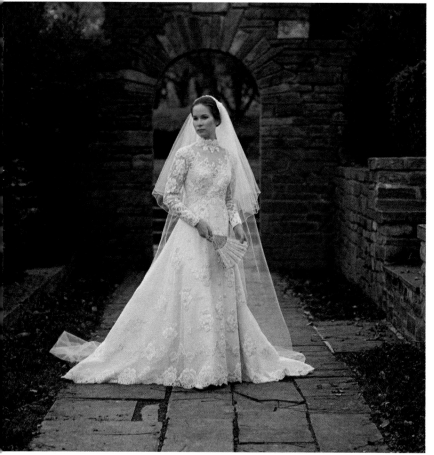

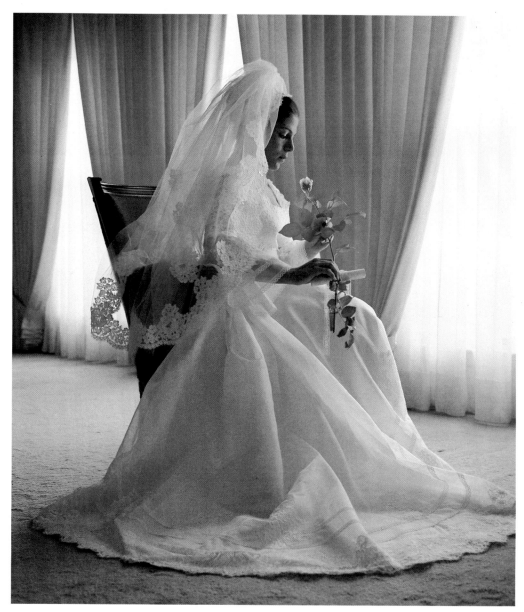

Rick Dinoian

"This full-length bridal portrait was made with a Hasselblad camera and a 150 mm lens at 1/30 second at f/4. It was taken very late in the day, just before sunset. All light was natural, but on the right side of the picture there was a hill, blocking some of the light from that direction. Almost all of the light was from above and the left side (open sky). The bride was turned away from the light so that it would cross over her gown and bring out the detail. Her face was turned toward the light so that it would model her features."

The golden glow surrounding this very formal bridal portrait is the planned result of the daylight streaming through the window-wall background. A golden Reflectasol reflector added warmth and detail to the shadows. No additional light was used. The camera was a Mamiya RB67 with a 90 mm lens; the exposure was 1/5 second at f/8; the film was KODAK VERICOLOR II Professional Film.

This automatically raises the front shoulder; the shoulder closest to the camera. If the head is tipped to the higher shoulder, it is considered a feminine pose. If the head is tipped to the lower shoulder, it is considered the masculine position. After the body is posed, the dress can be adjusted. The modern theory is to always keep the train of the gown behind the bride. If the train is to be seen, then the bride should be turned to a position where the train will become prominent. But in no case should the train be wrapped around the bride in an unnatural way that destroys the graceful lines of the bridal gown.

The hands should be formed gracefully and then the flowers can be brought in. The hands should appear to flow, and as a general rule, the edges of the hands are more pleasing than the back or knuckles when photographed. In the bridal formal, the hands should always be lower than the waistline in any picture longer than a head-and-shoulder portrait so that the bustline will remain visible. The eyes should appear centered from the camera position as often as possible. Try to guard against showing too much white of the eyes. The veil should not have any sharp angles to it, but should form gently flowing curves.

The basic rules of good posing are still and will always be valid.

My formal bridal portrait style is a combination of the formal bridal technique and theatrical stylings. I use a good deal of dance and ballet movements in my poses to give the feeling of movement. I spent years developing my style that first began with the classical forms, then slowly incorporated the dance movements. Since most of my subjects are not trained models or dancers, it is necessary for me to show and demonstrate to each of

my brides exactly my idea of how they might best look. So I do each pose myself and my subjects are able to follow me. In time, I can capture movement over the most static and rigid poses.

Always remember, that important, correct, and proper as the posing may be, the essence of any portrait is the bride's expression. The true value of your bridal portrait will depend on how you pose, how you light, and how you get the right expression.

Wedding photography was on-location photography. I had to take pictures under all conditions. Because I had to do my pictures when I could and wherever it was at the bride's convenience, I found it necessary to develop a system of lighting that permitted me to balance the light properly so that I could get a good negative. As I used the lights, I learned how to manipulate them so that I could get the effects I needed. I practiced long and hard to master my lighting techniques, and in the end I was rewarded with the knowledge that I could go to any location, whether indoors or out, and create studio-quality portraits in a matter of minutes. Many of my techniques were developed from my years of experience in the motion picture industry. My lighting techniques are carefully constructed so as not to appear as though I have added light unless, of course, my purpose is to create a special lighting effect to convey a mood or feeling. In such cases, I will deliberately use my lights to cause an unrealistic effect.

I use Norman 200B portable strobe lights for all of my work. Most of my pictures are done on KODAK VERICOLOR II Professional Film, Type S. And I use Hasselblad Cameras and all their lenses to create the effects I want. I use 35 mm cameras and many types

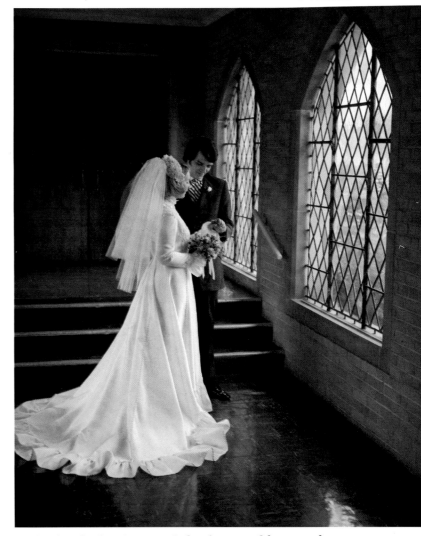

The Chapel: A location portrait that, because of the unusual position of windows, needed no auxiliary lighting.

"The Chapel was taken on a snowy day in February. The soft light from the overcast day kept the windows from burning out, yet the reflection from the snow gave enough illumination to provide both main light from the leaded windows on the right and fill from similar windows on the left, out of the picture. The full-length view gives lovely detail to the gown and yet the mood of the photograph is captured in the subjects' expressions.

"Taken with a Rapid Omega camera, a 90 mm lens, handheld at 1/15 second at f/3.5 on KODAK VERICOLOR II Professional Film, Type S, 220."

Wedding Portraiture, Today and Tomorrow

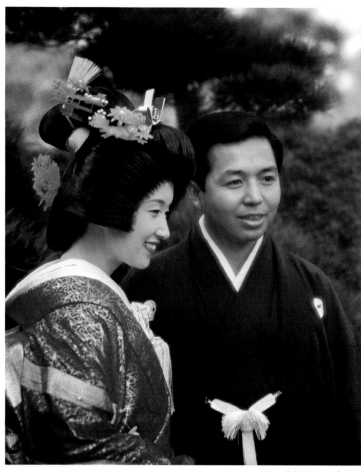

Kiyoshi Watanabe

of transparency material, usually KODAK EKTACHROME 64 Professional Film and KODAK EKTACHROME 200 Professional Film. In many of my pictures, I use one of the lights as a key light and sometimes I use a Reflectasol Umbrella to reflect light, and sometimes I use diffusers and snoots over the key lights. It all depends upon the results that I want to achieve. To support the key light, I will use additional strobe lights to balance out the rest of the picture, if the situation calls for support lights. Basically, I use the same principles as outlined in Kodak's first book on portraiture. The basic techniques of lighting and posing are all the same. It's how you apply and interpret the basics that make the difference.

The miracle days of making a picture are over. Nowadays everyone can make a reasonably correctly exposed negative. The professional portrait photographer must learn all the basic rules that comprise good portraiture. Then he must go out and develop his own personal techniques.

As a portrait photographer, you are constantly working with people. The basic fundamentals of lighting and posing can be learned in a relatively short while. What takes time is learning to deal with people. Once you can deal with people, you must learn to bring their feelings and their story out and put your point of view and interpretation of your subject into a photographic image. Furthermore,

the field of portraiture is again rapidly changing. It's not enough to simply get a well-exposed, comfortably posed, pleasing expression out of a person to become an outstanding portrait artist. There are chain stores turning out good clean photographs of people and offering services and prices that an individual studio owner would find very tough to compete with on price and service alone. The only answer for an independent studio owner is quality. He must offer a better product. That's all!

I feel that the future top portrait photographers will be oriented toward illustrative photography. They will create photographs that reflect the current images you can see in magazines, billboards, movie advertisements, record jackets, greeting cards, etc.

I feel that the future buyers of portraits will seek out photographers who can give them the things they have grown accustomed to seeing. The modern generation grew up with sound and video. They are attuned to seeing images — images of the now generation.

It is no longer viable to judge only the commercial competence of a portrait photographer's ability to produce photographic images that look like a decade ago no matter how well they are done. The future holds success for the portrait photographer who can combine the values of the time-tested past with the looks of today. There will always be a market for the old style of

This lovely couple was photographed with a 4 x 5-inch camera with a 240 mm Fuji soft lens at 1/30 sec and f/11 in open shade without further lighting. It is unusual to do this type of photography with a large-format camera today, but the beautiful quality of the negative and lens is certainly evident.

A soft and delicate portrait; unusual in that the faces of the bride and groom are semiobscured. Taken late in the day in a spectacular location.

"I love photography, and have practiced it for the last 10 years. Portraits, landscapes, fashion, nudes —and particularly the exotic Grenadine and Maldive Islands, Ceylon, Morocco, and Tunisia. I prefer shooting outside rather than in the studio with flash, for I love nature and life without stress. I hope, one day, to travel around the world, taking pictures for a publishing house."

Raymond Leroux

Wedding Portrait in the Far North: This bride and groom were photographed in their own home without the use of any additional photographic lights. The main light came from the window. Some additional warm light came from an overhead lamp. Petroleum jelly was added to a sheet of glass in front of the lens to increase the flare and to direct attention to the couple. The exposure was 1/15 sec with a normal lens.

The antique furniture and pictures on the wooden wall add personality and value to the composition.

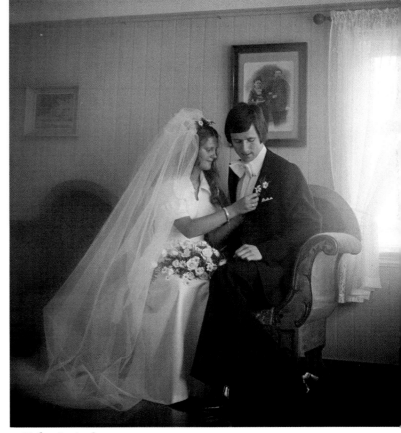

Peder Austrud

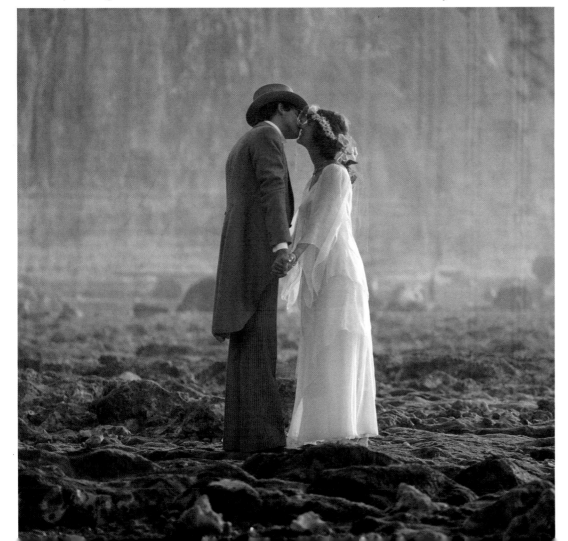

39

Wedding Portraiture, Today and Tomorrow

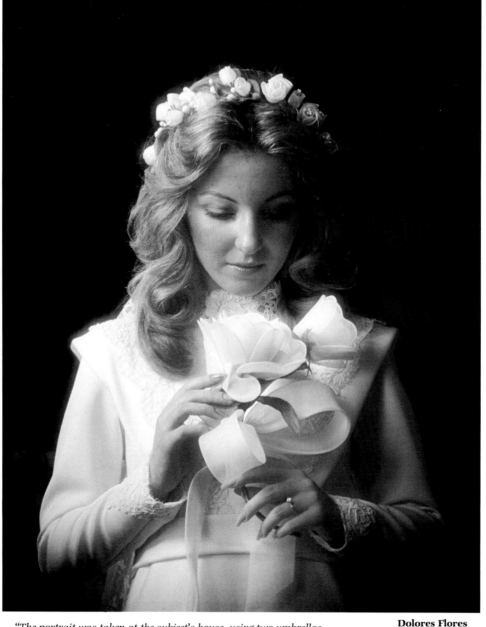

"The portrait was taken at the subject's house, using two umbrellas bouncing the light from electronic flashes. The fill light was obtained from reflection from the walls of the room. Behind the bride, two kicker lights were used with barn doors that were almost closed.

"A Hasselblad camera with a 150 mm lens and KODAK VERICOLOR II Professional Film, Type S, were used."

Dolores Flores

portraiture, but that market will be very small in comparison with what the rest of the market could be.

What does the market of today look like? That is very easy to answer. All you need do is open a newspaper and look at the movie advertisements or go to a record shop and look at the record jackets, or visit your local gift shop and look at the greeting cards.

At present, there are only a handful of photographers who have directed themselves to the new exciting field of illustrative portraiture. But I feel that more and more photographic artists will be entering the field in the coming years. I think there is a whole market out there waiting for innovative photographers to come and answer the need.

How do you learn to do this type of work? Watch the techniques of your top photographic advertising illustrators, your top magazine illustrators who photograph the models. Study the work of famous illustrators — the Avedons — the Penns — the Kanes — etc.

Wedding photography presents a unique set of problems. For one thing, you have a wedding dress to contend with. Another is that the wedding represents a beautiful tradition and the problem is to create the look of today and preserve the tradition of yesterday. I found a way that satisfies my artistic pursuit. I love the outdoors and believe in the beauty and power of nature. To me, it is always alive and in constant motion. I saw the possibility in outdoor bridal photography and was able to blend my philosophy with my techniques. I knew that anything that resembled a static pose would not match the flowing curvaceous lines of nature and I developed my style to coincide with that feeling. I add the elements of illustration to the natu-

J. Vergauwe

ral backgrounds and the results are modern and very pleasing.

Once you have achieved a level of competence, you will develop a personal style of your own "look." I believe that style emerges from your outlook on life. Your style is really a reflection of you — not someone else, you. Style comes from your life — your experiences, your blood, your sweat, and your tears. You must find out what you want to say and then how to say it in your pictures. For myself, wedding photography is a way to express romance. To me a wedding is really a time when two people agree to share their lives together. The wedding day itself is only an announcement of the relationship the two people hope to find with each other. I look at a wedding as an event that portrays love at a very beautiful moment in perhaps its purest and most ideal time. The wedding symbolizes the start of a new life for two people. The whole affair is really symbolic. After all, how often will the bride wear that dress again?

The wedding is a promise, a promise that begins with two people pledging to experience the adventures of life together.

Life, with all its ups and downs, joys and sorrows, laughter and heartbreak, is an ever-changing thing. In order for a relationship to succeed, it has to be able to accept change and to grow. I hope that my pictures will not only record the memories of happy moments but capture the romance of love so that whenever people look at their wedding photographs, they will remember their promise to each other and know that their romance is an ever-changing, always growing, lasting love.

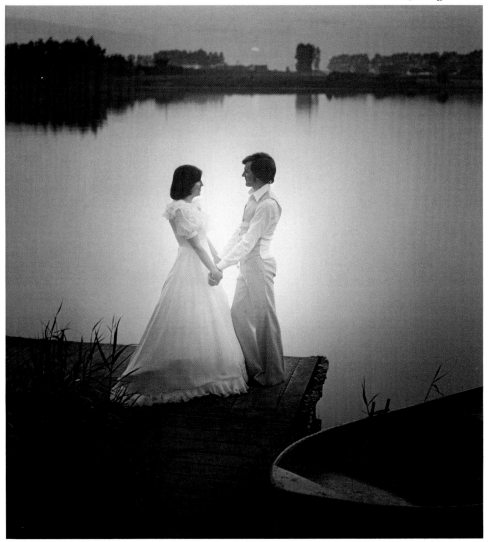

Backlighted by a setting sun against a beautiful lowland landscape, this newly wedded couple form part of a very carefully studied composition. Notice the receding planes of boat prow, landing, expanse of water, and finally the row of marching trees on the far bank, silhouetted against the evening sky.

Edward A. DeCroce

Location Portraiture

Proper Exposure with Electronic Flash

For the professional photographer, the word "location" has meanings not dreamed of by Webster. From the depths of a diamond mine in Africa to the tip of Mount Everest and even to the Sea of Tranquility on the Moon, competent photographers have contended successfully with technical difficulties. However, for the purpose of this chapter, we will define location portraiture as photography done in an indoor place other than the portrait studio. (Thus the photographer may very well elect to use umbrella equipment on location, and if he uses electronic flash in the studio, he should find the material on that subject in this section helpful.) Outdoor portraiture, with its entirely different set of problems, is discussed in a later chapter.

The trials of location portraiture are similar to those of studio portraiture, but they are compounded by unfamiliar territory and logistics. The complete control of his surroundings enjoyed by the photographer in his own studio is missing. Low ceilings, small rooms, and cluttered furniture frustrate him in many instances. The inability to make and evaluate test exposures in advance of the sitting adds immeasurably to his mental strain. Finally, even with today's small-format cameras and compact electronic flash equipment, the location portrait photographer needs a station wagon, a strong back, and a fantastic memory to arrive at his destination completely equipped to do a thoroughly professional job.

Why, then, is this type of portraiture becoming more and more popular? Primarily, because the public demands it. We are a society that is proud of its possessions. And we have more and richer possessions than

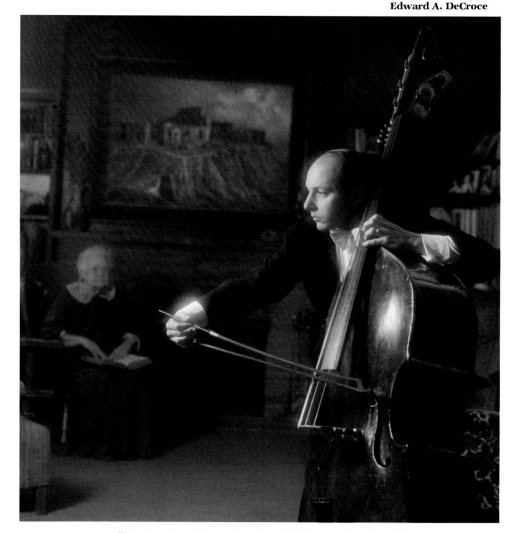

"Principal Bass—Denver Symphony: This is one of a series of 23 portraits, including those of 3 conductors and 19 first-chair musicians of the Denver Symphony.

"I selected my home as environment for an appropriate background and overall setting. Mrs. Kelly, the elderly lady in the background, was a model selected to add interest as well as continuity to the composition.

"A 200 watt-second electronic flash in an umbrella was directed onto the main subject from the left. A 50 watt-second unit, at the right, bounced from the white ceiling, provided fill. The Hasselblad camera, on a tripod, with a 150 mm lens and a Softar No. 3 filter was set at 1/15 sec, at f/8."

Carlos Bueso

This group of Puerto Rican businessmen represents a very difficult type of portraiture. Here the answer is in the simplicity of the lighting and the choice of a long lens. Two Balcar 600 watt-second electronic flash units were carefully placed at 12 and 15 feet from the center of the group at 90 degrees from each side of the camera. The 4 x 5-inch Graphic view camera was fitted with a 203 mm KODAK EKTAR Lens set at f/11. The long lens effectively prevented distortion of the subjects at each side of the group.

Location Portraiture

Al Gilbert

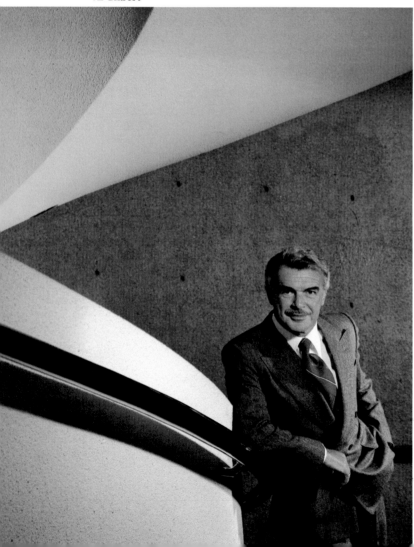

ever before. What more natural inclination, when the need for a portrait is felt, than to wish to be photographed at home, with your prized belongings? Now that it is technically possible, the smart photographer obliges — for an extra fee.

From the photographer's point of view, portraiture in the home, for all its inconveniences, produces very satisfying results. Since the subject is in familiar territory, expressions and attitudes are relatively more relaxed and natural. More importantly, the objects included in the photograph are not merely props from a closet but reflect the true personality of the sitter.

Location portraiture is not for the beginner. Full familiarity with equipment is essential because seldom will it be used as conventionally as it is in the studio. Rapid placement of lights and reflectors (without measurements or tests) to obtain the light ratio necessary for proper reproduction takes the experience of many studio portrait sittings. The ability to recognize the dangers in color reflections from green or blue walls into flesh tones, or the futility of allowing light from mixed sources (fluorescent or tungsten with speed light) to register on color film, comes from having viewed the results of many similar disasters — and having to retake the shots.

Location portraiture may be an expensive undertaking for the photographer because of travel time and cost, as well as the outlay for specialized equipment. Therefore, it must be relatively more expensive for the customer. Make sure that the quality of the resulting pictures is worth this extra expense. If possible, visit the location before the day of the sitting. Plan where the subject will locate and what will be included in the picture. Mentally plan the position of the lights, or make a rough sketch of the floor plan. Locate electrical outlets. (It's better to have electronic-flash units with their own power supply.) Investigate the possibility of using existing natural light. You will find that extensive planning will pay off in better, more professional photographic results. Start the actual sitting with simple sets and basic lighting. Don't experiment at first. Gradually increase the complexity of the setup as the sitting progresses. And finish by recording the unusual situations that often present themselves. By proceeding in this deliberate manner, you will find that your subject, when he sees the proofs, will choose the photographs he is attracted to by his personal degree of sophistication. Since all of the pictures contain familiar elements, chances of immediate acceptance of more than one of the poses are greatly heightened.

The craftsman who plans carefully and achieves technical perfection, as well as character delineation in his photographs, will work to a full schedule in a most interesting field.

Proper Exposure with Electronic Flash

Exposure with electronic flash is based on the distance from the flash unit to the subject. To determine the correct camera settings, proceed as you do when using flashbulbs. Divide the guide number by the distance from the flash unit to the subject. There are two differences, however: (1) With electronic flash, the guide number for a given film is the same at any shutter speed; (2) Usually the guide number must be determined by the photographer's tests of his own equipment rather than by consulting a printed chart. (See Negative Exposure, page 11.)

The guide number is the same at any shutter speed because the duration of the electronic flash is so short that even the fastest

This active executive portrait was made with two 3200 K quartz lamps — one far to the right and the other near the camera. Bounce light from the cast-concrete walls and ceiling acted as fill.
The film was KODAK VERICOLOR II Professional Film, Type L.

shutter speeds will catch the complete light output when the shutter is properly adjusted at X-synchronization. (Focal-plane shutters usually must be set at no faster than 1/60 second with electronic flash.)

The photographer must test his own equipment, because the light output of an electronic flash unit depends on several things: the energy supplied to the flash tube (measured in watt-seconds), the efficiency of the tube, the reflector, and the number of flash units fired from a single power source.

You can get greater flexibility of lighting control by using more than one light, just as in any method of lighting. However, two lights from one power pack will produce no more light than a single light from one power pack, but two units on one power pack do cut the flash duration in half.

Many manufacturers of electronic flash equipment furnish only the watt-second output of their power packs. It is up to the photographer to determine the actual amount of light, measured in beam candle power seconds (BCPS), or in effective candle power seconds (ECPS), that the particular combination of power pack, flash tube, and reflector delivers. The only practical way to do this is to make tests. Use a roll-film camera loaded with a reversal color film, such as KODAK EKTACHROME 64 Film (Daylight) (ASA 64). Place a subject exactly 10 feet from the flash unit, in surroundings similar to your normal backgrounds. Using the recommended shutter speed for your camera and flash unit, make a series of exposures at half-stop intervals. For the midpoint of the series, use the lens opening you think is correct for your film and flash combination. (A rough estimate is that a 100-watt-second unit delivers about 1500 to 2000 BCPS, a 200-watt-second unit, 3000 to 4000 BCPS, etc.) In each exposure, display a card marked with the *f*-stop used. Finish the roll of film by exposing the remaining frames on the same subject in full sunlight. Use an exposure meter to evaluate the exposure. Under normal viewing conditions, pick the processed transparency with the best exposure as compared with the outdoor frames. Multiply by ten the lens opening used to make that exposure. The answer is your guide number for that combination of film and flash.

Once you have the guide number for one kind of Kodak film, you can find the guide number for any other film by using the table below. Find your guide number opposite the ASA rating you used for the test. Any of the guide numbers listed in the same vertical column will work for your equipment and for any other conventional camera films with listed ASA ratings. Divide the guide number by the distance from the flash unit to the subject to determine the proper *f*-stop to use.

Guide Numbers for Electronic Flash

| SPEED | | OUTPUT OF ELECTRONIC FLASH UNIT (ECPS or BCPS) |
| | | 350 | | 500 | | 700 | | 1000 | | 1400 | | 2000 | | 2800 | | 4000 | | 5600 | | 8000 | |
ASA	DIN	Feet	Meters	F	M	F	M	F	M	F	M	F	M	F	M	F	M	F	M	F	M
10	11	13	4	16	5	18	5.5	22	6.5	26	8	32	10	35	11	45	14	55	17	65	20
12	12	14	4	18	5.5	20	6	24	7	28	8	35	10.5	40	12	50	15	60	18	70	21
16	13	17	5	20	6	24	7	28	8	32	10	40	12	50	15	55	17	65	20	80	24
20	14	18	5.5	22	6.5	26	8	32	10	35	11	45	14	55	17	65	20	75	22	90	27
25	15	20	6	24	7	30	9	35	11	40	12	50	15	60	18	70	21	85	26	100	30
32	16	24	7	28	8	32	10	40	12	50	15	55	17	65	20	80	24	95	29	110	33
40	17	26	8	32	10	35	11	45	14	55	17	65	20	75	22	90	27	110	33	130	40
50	18	30	9	35	11	40	12	50	15	60	18	70	21	85	26	100	30	120	36	140	42
64	19	32	10	40	12	45	14	55	17	65	20	80	24	95	29	110	33	130	40	160	50
80	20	35	11	45	14	55	17	65	20	75	22	90	27	110	33	130	40	150	46	180	55
100	21	40	12	50	15	60	18	70	21	85	26	100	30	120	36	140	42	170	50	200	60
125	22	45	14	55	17	65	20	80	24	95	29	110	33	130	40	160	50	190	60	220	65
160	23	55	17	65	20	75	22	90	27	110	33	130	40	150	46	180	55	210	65	250	75
200	24	60	18	70	21	85	26	100	30	120	36	140	42	170	50	200	60	240	70	280	85
250	25	65	20	80	24	95	29	110	33	130	40	160	50	190	60	220	65	260	80	320	95
320	26	75	22	90	27	110	33	130	40	150	46	180	55	210	65	250	75	300	90	360	110
400	27	85	26	100	30	120	36	140	42	170	50	200	60	240	70	280	85	340	105	400	120
500	28	95	29	110	33	130	40	160	50	190	60	220	65	260	80	320	95	370	110	450	135
650	29	110	33	130	40	150	46	180	55	210	65	260	75	300	90	360	110	430	130	510	155
800	30	120	36	140	42	170	50	200	60	240	70	280	85	330	100	400	120	470	143	560	170
1000	31	130	40	160	50	190	60	220	65	260	80	320	95	380	115	450	135	530	161	630	190
1250	32	150	46	180	55	210	65	250	75	300	90	350	105	420	125	500	150	600	180	700	210
1600	33	170	50	200	60	240	70	280	85	340	105	400	120	480	145	560	170	670	205	800	244

Photographing Children and Young People

By Leon Kennamer

More than half of my photographs each year are portraits of children from 6 months to 16 years of age. These young people seem more at ease in a natural environment than under studio lights, so outdoor portraits are a "natural" for them—and for me.

For outdoor sittings I suggest casual and comfortable clothing in colors that will blend rather than clash with the natural backgrounds. A clothing conference, held before the sitting, helps the subject or parent of the subject to understand that simplicity is our aim and the child rather than the clothing is our primary concern. I recommend muted colors and patterns, avoid the raw, hot, colors—bright yellow, lime, orange, intense red, etc—and large, distracting designs.

White socks and/or white shoes, very popular in some sections of the country, particularly with more formal clothing for the very young child, may be toned down by selective vignetting or by placing the feet behind some foliage. (To avoid foreshortening, the feet should not project directly toward the camera.) Sometimes the shoes and socks, and even the shirt may be removed for a very casual look. Personally, I prefer to photograph children outdoors in play clothes and indoors, with artificial light in the studio, in formal clothes, thus creating a market for both types of portraiture.

I feel that the photographer should dress more casually for an outdoor appointment,

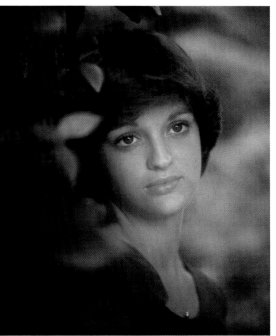

Leon Kennamer

The art of portraiture is the art of arranging light. In the studio, this means adding light where it is needed. In the out-of-doors, it often means finding ways of eliminating natural light that is not wanted. Here is a typical example:

"On the left, the tree itself acts as a light subtractor or deflector to give vertical shadowing to the face. On the right, a 42-inch black Reflectasol panel deflects and absorbs the high overhead light, thereby eliminating cross lighting and unflattering shadows."

Leon Kennamer

Casual clothing was in order for this portrait.

"I carry a sturdy light stand with me for use in situations such as this. Here it holds a 42-inch black Reflectasol panel to block the overhead light and eliminate 'down' shadows. Notice that the elimination of the overhead light on the subjects does not affect anything else in the picture."

Leon Kennamer

"In a relatively open woodland. Two 42-inch Reflectasol black panels were used—one overhead to absorb the skylight and prevent those undesirable 'down' shadows under the eyes, nose, and chin; and the other on the right side to absorb the light from that direction, thus preventing overfilling of the shadow side. This system of building portrait lighting in the out-of-doors by subtracting unwanted illumination is fascinating and effective.

"Notice that the expressions in my portraits are ones of repose. I feel that a picture of a face that is relaxed is easier to look at for long periods of time."

Leon Kennamer

"A simple and happy little portrait. Thick overhanging foliage blocked undesirable overhead light, leaving the flattering, soft ambient illumination. The introduction of the diagonally placed, neutral-colored logs effectively breaks up an otherwise static vertical composition."

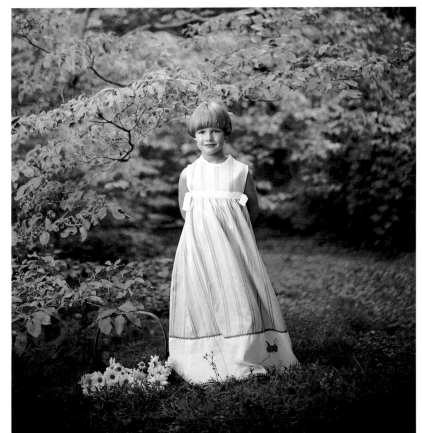

Leon Kennamer

"Simplicity of position is the key to the charm of this woodland portrait. A 42-inch Reflectasol black panel, held over the child's head with a light stand, eliminates the dark shadows produced by top light. The basket of flowers provides a substantial base to the composition, and the diagonal lines of the sweep of the long skirt give an impression of movement. A vignetter was used to darken the bottom and corners of the negative."

47

Photographing Children and Young People

M. Sawada

"A Merry Summer Festival: It is important for a photographer to be able to make exposures quickly and in rhythm with the subject when photographing children. The lack of grain in KODAK VERICOLOR II Professional Film has made it possible for us to use a diminutive camera, even in the studio. The film renders excellent shadow tones, and these areas must be kept relatively dark. Care, therefore, must be taken to attach barn doors to each light source so as to direct the illumination away from the shadows.

"Quick adjustment of the light ratio to meet changing photographic concepts is possible by changing the light-to-subject distance according to measured marks on cords attached to each electronic flash unit."

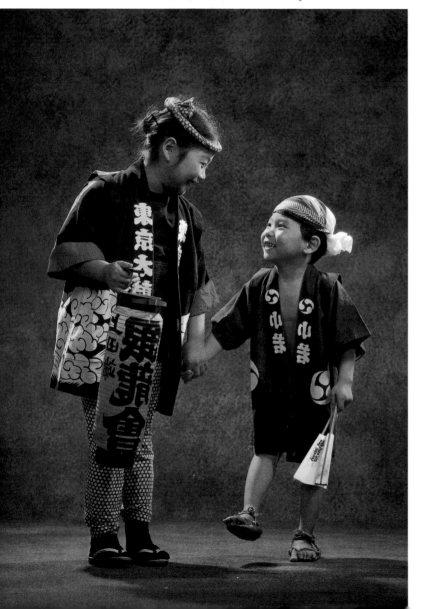

avoiding the appearance of an authority figure. Be a companion or playmate, on the child's level, rather than a distant "professional." Because I usually photograph in subdued light with maximum apertures and slow shutter speeds, I use a tripod, one that allows me to work down at the child's level. I recommend a long cable release to aid the photographer in directing the child's attention away from the camera.

When photographing very young children, it is usually advisable to have one (but not both) of the parents accompany the child. If too many people are present (especially grandparents or other children), the child may become confused about where to direct

his attention. Some parents tend to overprepare a child for a portrait session, resulting in grimaces, artificial smiles, or hyperactivity. With a shy or antisocial subject I may pretend to ignore the child, entering into a conversation or some play activity with the parent until the child begins to take an interest in what we are doing. Children are naturally curious and usually enjoy learning something new, if it is presented as a game. Remember that it is almost impossible to create a pleasing likeness of someone who does not want to be photographed. The relationship between members of the family—how they interact with one another—may be explored at least briefly before attempting to make group photographs.

Simple two-unit electronic flash lighting is effective for this classic mother-and-child portrait. One unit high and to the left as the main illumination is balanced by a unit close to the camera. The dark background and shaded foreground focus attention on the subjects' expressions. Delicate fabrics add softness.

Preston Haskell

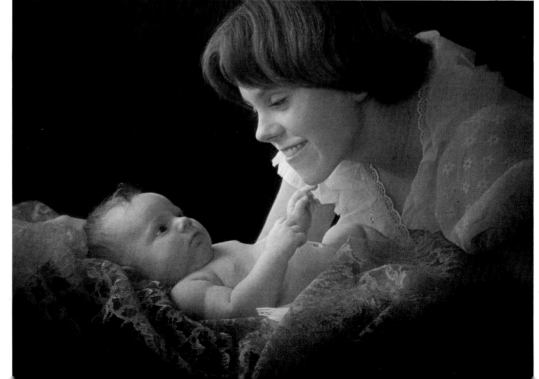

Rarely, if ever, is it prudent to have a teenager of the opposite sex accompany a teenage subject unless the two are to be photographed as a couple—the friend tends to compete with the photographer for the subject's attention. Also, it is unwise to have a parent accompany a teenager, as there may be some differences of opinion (The Great Generation Gap) concerning grooming, clothing, attitudes, and expressions.

Nature abounds with a variety of props: trees to lean on; rocks to sit on, and twigs, leaves, and flowers to hold. I seldom use an indoor prop outdoors, but I have photographed children with fishing poles, old books, or baskets of cut flowers to create a certain mood.

As to posing, I prefer to let children do what they will with a minimum of manipulation, photographing them at the moment they assume a pleasing attitude. (I am trying to use the word "attitude" in preference to the word "pose," which has a connotation of precise placement of limbs and direction of gaze—too mechanical an approach for me.) A photographer must be able to establish rapport with the subject, drawing forth or evoking, rather than forcing, expressions that will be pleasing. I prefer faces in repose or with a softer expression because an overly exaggerated expression tends to become tiring to the viewer after a while.

To recognize a pleasing attitude, a photographer must have some knowledge of correct composition and correct subject-to-background relationship. Some of the elements affecting the visibility of the subject against the background are: the color of the background, the amount of light on the subject and on the background, and the distance from the background to the subject. To the eye, light objects seem to come forward, darker objects seem to recede; warm colors excite, cool colors calm; and distinct objects are easier to view than indistinct ones. It follows, therefore, that if a subject is lighter, warmer in color, and more distinct (in focus) than a background, it will be most dominant in a photograph.

Working with the medium-format camera (2¼ x 2¼-inch, with 150 mm, 180 mm, or 250 mm lenses) at maximum aperture, restricts the effective depth of field, creating the out-of-focus background we want. It still allows use of the fastest shutter speed possible in subdued open shade. Even with a fast film such as KODACOLOR 400 Film, I would use a wide aperture and adjust only the shutter speed. When using the maximum aperture on a longer-than-normal lens (150 mm, 180 mm, or 250 mm), remember that ⅓ of the depth of field is from the point of focus toward the camera and ⅔ of the depth of field is beyond the point of focus. Thus we find that in focusing on a catchlight in the eye, there may not be enough depth of field to include the tip of the nose; it might be more practical to focus on the tip of the nose and let the ⅔ include the eyes and the mask of the face. This method also allows for a slight "sway" of the subject—very important when dealing with fast-moving small children. The problem exists primarily in close-ups; backing away for a longer view increases the depth of field even at the same aperture. Further reduction of the problem of subject sway can be accomplished by photographing subjects near, or leaning on, trees, rocks, or rustic buildings. This procedure also gives the photographer additional vertical light control, using an existing object to block unwanted light.

Long shadows from the low main light add drama to this delicate portrait. The diffused fill light was moved quite a distance to the right of the camera to allow those shadows to register.

A studio camera with a 16-inch KODAK Portrait Lens, and 5 x 7-inch KODAK EKTACOLOR Professional Film recorded the image illuminated by two 20-inch Photogenic Studio Master electronic flash units.

Jay Stock

Photographing Children and Young People

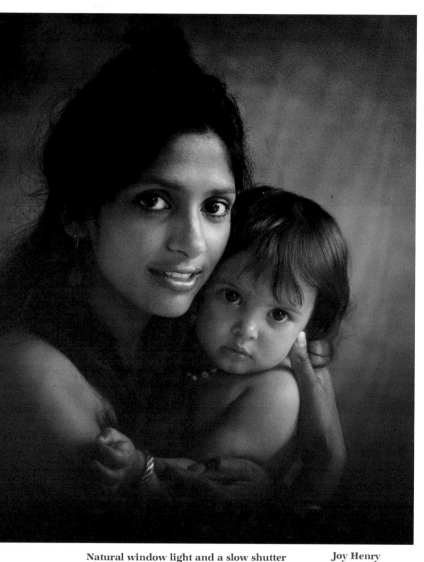

Natural window light and a slow shutter speed captured this mother and daughter. The subtle fleshtones and delicate highlights seem to be recorded with more fidelity with such natural illumination. Exposure was 1/30 sec at f/4.

Joy Henry

To improve light in an outdoor location, first analyze the type of light available, then decide what is to be accomplished with this light in shaping the face and achieving a pleasant likeness. I prefer to work in open shade at a time when the background is also in shade. The primary light source is open sky and direct rays of the sun are generally used as backlighting.

Under these conditions, the predominant problem is the high overhead light, the light that casts deep shadows under the brows and broadens and flattens the appearance of the nose. There are several ways to control this unflattering source of light. I suggest placing the subject under the overhanging roof of a porch, barn, or shed, overhanging leafy limbs, or some type of light control device correctly set up on a light stand. (For convenience I use the portable folding, black Reflectasols, manufactured by Larson Enterprises.) The correct placement of a light control device must be learned by practice, testing, and experiment. The basic rule to re-

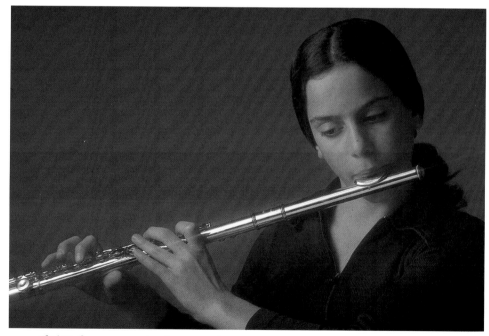

Christopher

The Flute Player: "A studio portrait — my daughter actually playing my favorite music for me.

"I used a blank gray wall as a background, with no background light, no hair light or fill except the reflections bouncing off light-colored walls. The one-and-only source of illumination was bounced into a large umbrella.

"With a Nikon camera at f/2 on a 105 mm lens with a homemade diffuser and on KODACHROME 25 Film."

member is: Use light controls, just as in a studio, to create a more pleasing likeness. Be sure to read the exposure meter with all the light control devices in position. Outdoor lighting is soft and subtle and must be observed from no farther than arm's length away from the subject. From the camera it often appears flat and lacking in contrast. With the recommended practice and testing, I feel that many photographers will be able to achieve very beautiful results using the system of "subtractive lighting." Light control devices set up on light stands are easy to carry on location and I find that small children are fascinated with the idea of a child-sized tent as part of my play with them. Trees, foliage, or an additional control device to one side of a subject can aid in blocking unwanted light—again I emphasize—to improve the lighting, to create a more pleasing likeness.

One cannot control light until one sees it. Continuing to observe lighting from arm's length, becoming familiar with the subtractive lighting system, testing to determine the correct exposure for the low-light level—all of these guidelines will help to improve negative quality, resulting in the production of much better photographs.

Learning to observe children in their natural attitudes, learning how to play with a child constructively, learning how to create the pleasing likenesses the parents want—all will help to improve your public relations image—and your portrait sales.

The essence of childhood's exuberance is captured in a high-key electronic-flash portrait. High-speed studio flash units will freeze all but the ends of the hair if they are not used at their peak wattage. Lower wattage or extra flashtubes will shorten the duration of the flash, giving faster speed but less concentrated light.

Hans Jorgen Brun

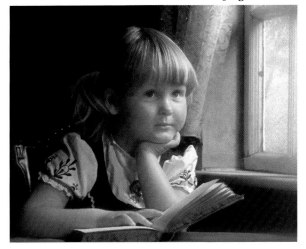

This is a studio set, not on location. The window is in a flat; the trees on a painted poster. The main light comes through the window, with a fill to the right of camera plus a reflector to the left.
Photo-illustration portraiture, such as this, is fascinating work.

Hans Jorgen Brun

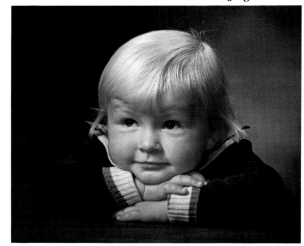

A simple, but appealing, portrait. Lighting consisted of a main light at almost 90 degrees to the left of the camera, and a background light. The impact of the picture lies in capturing the impish character of the child in an angelic face.

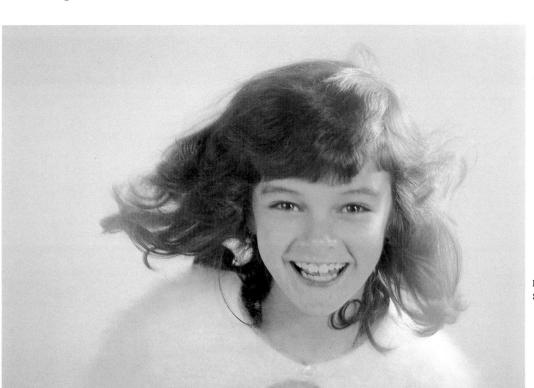

Foto Studio Schuhmacher

51

Stanley Gordon Richards

Simply beautiful might be the phrase to title this photograph. The soft natural sunlight from the right models the child's cheek. A slight fill from a 24-inch silver reflector lowers the contrast on the left. A huge tree trunk acts as both background and black reflector to cut the overhead illumination and to prevent dark pockets of shadow from forming under eyebrows, nose, and chin.

Damien Waring

Mother and Baby: *"Lighting: A 1200 watt-second electronic flash in a soft white umbrella as a main. The background was flooded with two 200 watt-second units directly angled toward the white wall but purposely allowed to spill onto the subjects, creating soft or blurred image lines."*

An important event in the life of a young lady can be the inspiration for a great variety of photographic portraits.

"The photo was taken under a roof in one of the corridors of a (Spanish) colonial house. Illumination was from available sunlight coming over the far wall. A small flash unit near the camera added fill light directed toward the subject. A Mamiya RB-67 camera with a 127 lens and KODAK VERICOLOR II Professional Film, Type S, were used."

Babes in the Woods: *"This portrait was taken in the Wisconsin forests during a teaching seminar.*

"Two tiny toy animals were presented to the boys at the last moment to give them something to do with their hands. I was careful to minimize the white stockings by partly concealing them with ground cover. The partly overcast lighting helped reduce contrast and provided roundness and depth to the flesh and background. Although this is a rather uncontrolled situation, I like the print. It has been darkened top, bottom, and sides. The little V at the top between the trees was darkened as well as was the hair of the older boy."

Basic Lighting for Portraiture

This chapter will be concerned with some of the conventional lighting techniques used by professional photographers on a day-to-day basis to produce artistic and salable likenesses of their customers. These are, for the most part, basic and uncomplicated lighting methods. Consider them stepping-off points for your own innovations.

To some readers, these procedures may be a form of review, yet perhaps a suggestion here or there might help them correct a lighting flaw that has remained unnoticed. Perhaps a method will suggest a new way to more efficient camera room techniques or more artistic results.

Hopefully, the newcomer to photography, or the commercial or industrial photographer called upon to make an occasional portrait, will use this material as a primer in learning basic portrait lighting.

Definitions

The goal of the portrait photographer is to idealize his subject. His tools in achieving this end include the pose, camera angle, lighting, and retouching—but of all of these, the most pliable is the lighting.

The proper lighting can create modeling and realism: Using the concept that light areas of a print project and dark areas recede, place highlights on the five frontal planes of the face (forehead, nose, chin, and both cheeks) with the neck and sides of the face in shadow. This helps lend a desirable third-dimensional effect to the subject.

Equally important, the lighting can be used to idealize: facial defects can be obscured in a shadow; a broad nose can be narrowed by employing a short lighting of the "split" variety.

Probably the most basic single principle governing portrait lighting is that there should be one dominant light source, with all other lights subordinate and subservient to it. Accordingly, the character and placement of the main, or key, light in relation to the position of the subject is of primary consideration to the portrait photographer. Its placement is used as a means of classifying the four main types of lighting as follows—

Broad Lighting: The main light illuminates fully the side of the face turned toward the camera. Although this lighting helps to de-emphasize facial textures, it is used primarily as a corrective lighting technique to help widen thin or narrow faces.

Short Lighting (Sometimes known as "narrow" lighting): The main light illuminates fully the side of the face turned away from the camera. This lighting is generally used for the average oval face of either a man or a woman. It tends to emphasize facial contours more than broad lighting and, in conjunction with a comparatively weak fill light, can be used as "strong" or "masculine" lighting especially adaptable for low-key portraits. Short lighting has the effect of narrowing the face and therefore can be used effectively as a corrective lighting technique for round or plump faces.

Rembrandt Lighting: A combination of short lighting and butterfly lighting. The main light is placed quite high and on the side of the face turned away from the camera. Named after the famous Dutch painter, who illuminated his models by means of a trapdoor in the studio ceiling.

Main Light

1 Broad

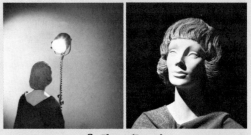

2 Short (Loop)

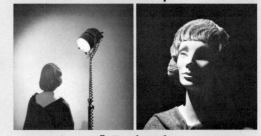

3 Rembrandt

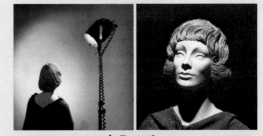

4 Butterfly

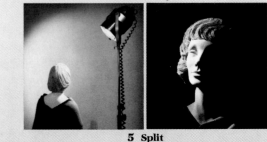

5 Split

Types of Main Lights

| Spotlight | Floodlight | Umbrella |

Auxiliary Lights

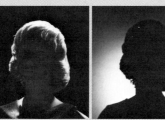

| Fill light | Hair light | Background light |

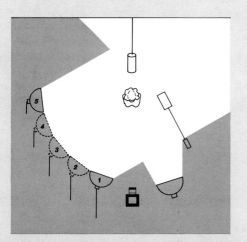

The numbers of the main-light positions (1 through 5) are equivalent to the illustration numbers on page 54.

Complete

Broad

Short (Loop)

Rembrandt

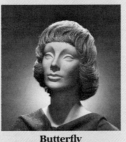

Butterfly

Split

Butterfly Lighting: The main light is placed directly in front of the face and casts a nose shadow directly underneath, and in line with, the nose. Butterfly lighting is used most successfully with a normal oval face and is considered a type of glamour lighting especially suitable for young women. It is not usually suggested for men because of the way in which the subject's ears might be highlighted and made undesirably prominent.

Lighting Variations

Bounce Light: From these four basic lighting positions for the main light, any number of derivations can be achieved. From the broad lighting position bounce light is derived. This is accomplished by aiming the main light directly away from the subject to a suitable reflector. The light that is reflected to the subject is soft, shadowless, and most flattering. Often no fill light is used, or perhaps only further bounce from another reflector on the far side of the subject to open up or soften the shadows.

Direct Light: Another derivation from the broad lighting position is so-called direct light. The main light in direct lighting is a high, reflectorless unit that throws an overall sun-like illumination on the subject. Usually directed on the side of the subject turned toward the camera, the direct light is more directional than bounce light and gives more highlight separation. Fill-in is accomplished by an auxiliary light source or large reflectors.

Window Light: A popular use of the short lighting position is window light. Usually a combination of daylight and auxiliary electronic flash, it produces a natural, soft, low-key portrait. The subject is placed beside a window lit by skylight, not direct sunlight.

Basic Lighting for Portraiture

The fill unit is on or near the camera and is ½ or less the intensity of the window light. If you are shooting with color film, be careful that the color temperature of your artificial fill light agrees with the natural daylight coming in the window. (Photographic daylight is considered to be 5500 K.)

Split Light: The main light can be moved far enough behind the subject so that only half of the face is highlighted and there is no triangular patch of light on the nearest cheek. This variation of short lighting, known as "split" lighting, is used only rarely, and then to produce moderately dramatic low-key effects, conceal facial defects in the shadow side of the face, or slenderize a very broad nose.

Ceiling Bounce: One of the most widely used forms of bounce lighting, where the electronic flash unit is on the camera and pointed directly up, it automatically gives the results of a softened butterfly lighting position. Once again, fill-in can be accomplished by reflectors placed horizontally under the subject's chin, or by white floors.

Drawbacks to this form of butterfly lighting are the necessity for white ceilings and the lack of specular highlights in the photographic subject's eyes. (A 3 x 5-inch card, taped to the flash head, will receive some direct light from a unit aimed at the ceiling, and this will add sparkle to the eyes. It will also relieve shadows caused by eyeglasses.) However, used with a reflex-type camera, ceiling bounce is an ideally portable source of illumination for following a small child in a high-key studio.

These are only a few variations of the four basic lighting positions of the main light. Of course, to do a professional portrait with one light is possible, and it is often done to achieve a special effect. Normally, however, a portrait photographer uses a number of lights to build a suitable lighting for the subject. While no two photographers proceed in exactly the same way, you should follow an efficient, consistent operating method of adding lights to a portrait set. The list of individual lights might be the following, in this order:

The Background Light: Customarily, the background light is a small floodlamp on a short stand placed about midway between the subject and the background. Its purpose is to help provide tonal separation between the subject and the background and, when color film is used, to control the color and general rendition of the background. Although it is a matter of personal preference, some photographers start the lighting buildup by adjusting the position of the background light. Exact placement of this light can be achieved more easily when its effect can be observed by itself. Placement of the background light is facilitated if the photographer will first direct it toward the subject, watching the shadow the modeling light casts. The subject's shadow should completely cover the camera, thus making sure that the lens will not see any part of the background light itself. The background light is then rotated 180 degrees and final placement adjustments are made.

The Main Light: Generally, this is a floodlamp or broad light source located higher than the subject's head and at approximately 45 degrees to one side of the camera-subject axis, usually in the short-light position. One method of placing this light properly, using the modeling lights, is to watch the resultant catchlights in the subject's eyes. As seen from the camera-lens position, these catchlights should be located at approximately the one o'clock or the eleven o'clock position in the eyes, depending on whether broad or short lighting is used and on the direction the subject is facing. Obviously, these catchlight locations will vary somewhat from subject to subject. For example, for a person with deep-set eyes or a person wearing a wide-brimmed hat, the main light will have to be lowered somewhat from the normal. However, the important point is that the main light must cause catchlights high in the eyes; otherwise (if it's too high, for instance) the eye sockets will appear to be excessively dark and recessed. About the only reason for using the main light very high would be to emphasize forehead wrinkles as much as possible,

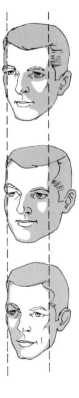

A normal, oval face and conventional short lighting. Note that the main light has been positioned laterally so that it places a triangular highlight on the cheek nearest the camera.

A wider-than-normal face. In order to make it appear more normal, the main light has been moved further to the left and the width of the triangular highlight reduced.

Highlighting a comparatively greater area of a narrow face can make it appear somewhat wider. Thus, the width of the highlighted area of the face in any portrait should be about equal, regardless of the facial type.

as in character-study work. Obviously, this won't do for day-to-day, salable studio portraits.

Most photographers use a diffused main light because a sharp shadow from the main light is not so desirable in portraiture as it is in commercial product photography. Diffused lighting minimizes facial textures, helps to minimize retouching, and, accordingly, is used most often for conventional portraits of both men and women. As a matter of personal preference, a few photographers use an undiffused main light for men, to accentuate character lines in the face or to produce a brilliant glamour effect. This lighting is more difficult to control and is used more for special effects or salon results than for bread-and-butter portraits.

The next question to be answered is, should you use short or broad lighting? Discounting personal preference, the subject's facial structure provides the answer. The average oval face is presented most flatteringly with short lighting; the broad face, also with short lighting; and the narrow face, with broad lighting. The above diagram illustrates these three basic situations.

Note that the width of the highlighted area for all three subjects is approximately the same. The lighting has been designed to idealize the narrow and the broad faces and present them as normal. The basic consideration is that the broader the face, the more of it should be kept in the shadow; and, conversely, the narrower the face, the more of it needs to be highlighted. It is for this reason that the triangular highlight on the broad face is intentionally smaller than the equivalent area on the normal face. The reduction of this cheek highlight is accomplished, of course, by moving the main light slightly farther behind the subject. This is a delicate adjustment. Its effect can be judged accurately only from the camera lens position.

Broad lighting, used less frequently than short lighting, requires additional care and skill. The broad position of the main light means that too great a portion of the near side of the subject's face, including the ear, will be highlighted excessively. To keep this area in shadow, some means of controlling the distribution of light must be used. This shading can be accomplished by means of feathering the main light, or adding barn doors or head screens. Obviously, a combination of these methods can be used.

The Fill Light: Generally, the fill light is diffused, used close to the camera at lens height, and placed on the side of the lens opposite that of the main light. Some slight modification of this position may be necessary for people wearing glasses, to avoid specular reflections.

The lateral position of the fill light is determined to some extent by the specular facial highlights this light causes. The effect must be observed carefully from the lens position. If, for example, a person has a type of skin that reflects the image of the fill light too strongly when the light is close to the camera, these peculiar highlights can be reduced by moving the fill light slightly away from the camera. Often, this adjustment is critical in controlling the degree of highlight brilliance and, as mentioned before, the effect must be carefully observed from the lens position.

Another consideration in the lateral position of the fill light is that undesirable shadows caused by smile lines may be created by using this light too far from the camera axis.

Almost inevitably, the fill light will add a lower pair of catchlights to the eyes. These secondary catchlights are usually considered

A "feathered" light refers to the fact that the subject is illuminated by the peripheral area of the light cone. Generally, the light is feathered in such a way that the reflector axis is in front of the subject.

In a broad-lighting situation, an alternate method of shading the nearest ear is to use the barn-door baffle attached to the lamp reflector. Barn doors are also useful in shading white blouses or bald heads.

A head screen has the advantage of more positive shading control since it can be used independently of the subject. Two screens will be useful as studio accessories.

Basic Lighting for Portraiture

objectionable, not so much because they tend to belie the basic principle of one main light source but because they often create the impression that the subject has a directionless stare (a starry-eyed effect). Consequently, this second pair of catchlights should be removed. This can be done either by etching them on the negative (if a black-and-white film was used) or, more easily, by spotting them on the print (which can be done on either black-and-white or color prints). Color negatives cannot be etched successfully, due to the layer construction of the emulsion.

Be sure to check the section "Lighting Ratios" on page 12 for additional information regarding exact placement of the fill light.

The Hair Light: This small lighting unit, generally used on a boom from above and behind the subject, is almost a necessity. It not only adds some detail to the reproduction of the hair but also provides a useful means of subject-background separation.

There are three general positions relative to the subject where the hair light can be used effectively: directly overhead, either to the right or left of the hair at head level, or above and to one side. In any case, the hair light should seldom be allowed to spill over onto the face, since this may cause small but distracting highlights and belie the basic principle of a single light source. A suggestion for placing the hair light properly is to bring it forward gradually until its illumination just strikes the forehead or the cheeks, as the case may be, and then move it back until the highlight on the skin disappears.

Aside from the photographer's personal preference as to the rendering, the color, and especially the degree of sheen of the hair, dictate the amount of hair illumination required. Brunette hair requires more intense illumination than blond; dull hair, regardless of color, requires a relatively intense hair light in order to restore a desirable sparkle. The actual intensity is something that cannot be learned from a book—it is a matter of experience in recognizing an artistic visual balance in the studio.

The Backlight: Often referred to as a "kicker," the backlight finds most use in outlining the shoulders of men's dark suits, to separate them from dark backgrounds. It is also helpful in adding detail to hair and, in rare instances, of dramatic portraits, as a facial backlight. This lighting unit, generally a spotlight, is used slightly above the height of the subject's head and usually, but not always, on the same side of the subject as the main light. If used properly—better too little than too much—and from the same side of the subject as the main light, it can help add strength to a masculine face when it rims or grazes the extreme edge of the face. When the backlight is used on the opposite side from the main light, it often creates an undesirable effect by outlining the ear and making it appear to pull away from the head.

A precaution in using the backlight is that it usually should not be allowed to strike the tip of the subject's nose. If it does, it may give an abnormal appearance to the nose. Just a slight repositioning of either the light itself or the subject's head can prevent this lighting error. Be sure that both the hair light and the backlight are turned off when an exposure-meter reading is being taken. Not only do these lights have no effect on the basic exposure, but the danger is that they may influence the meter incorrectly. And, of course, no backlight should shine directly into the camera lens since this might cause glare and would reduce the image contrast. A "barn door" or "snoot" can be used to shield the lens from this spill.

Highlight Brilliance

"Highlight brilliance" usually refers to the degree of specularity of facial highlights. The principles governing this important aspect of facial rendition should be very familiar to portrait photographers. Generally, most photographers strive for an artistic midpoint between the two extremes of rendering a face so that it appears perfectly matte and rendering it with such strong highlights that it appears excessively oily. The desired degree of highlight brilliance is sometimes influenced by local public taste and individual photographic style. However, it should be kept in mind that, up to a point, the more brilliant the facial highlights, the more three-dimensional the rendition becomes. Of course, this effect can be overdone and when it is, the result is especially unfortunate in color portraiture because the skin color will then be lost in resulting prints.

Most of the necessary control over highlight brilliance can be provided by a slight lateral movement of either the main or the fill light or both. It is absolutely necessary to appraise these effects from the position of the camera lens, however. If additional controls are needed for certain subjects, they can be furnished by either of two means. The first is applying makeup to the subject. Powder can be used to reduce excessive facial reflectivity, cold cream, applied judiciously, to increase highlight brilliance. The second lies in the lighting. The larger and more diffused the frontal light, the more matte the face will appear; conversely, small and undiffused lights cause the most pronounced highlight brilliance.

As an occasional technique some photog-

raphers use in addition a small, undiffused light called a "highlighter" above and in front of the subject's face to reinforce the highlights by adding to their specular appearance. This light should be fairly weak; it should cause no discernible shadows of its own when used in conjunction with conventional lighting, and it should not be used so far forward as to add additional catchlights to the eyes.

In either black-and-white or color, beware of obliterating the delicate facial highlights by overexposing the negative.

Camera Height for Normal Perspective

One of the most important decisions you make at the outset of a portrait sitting is at what height to place the camera in relation to the subject. A series of factors influences this decision. The first factor is the amount of the figure you are going to include in the photograph. For normal perspective in a head-and-shoulders portrait, place the camera level, with the optical axis of the lens at the height of the subject's lips and tip of the nose. For a ¾, or full-length figure, lower the camera until the center of the lens is level with the upper chest. For a full-length figure in the fashion style, lower the camera again until it is level with, or a little below, the waist. This low position will produce an increased feeling of grace but makes for a tiny head.

Another factor affecting the choice of camera height is the shape of the subject's face and how you would like to influence the way it is rendered. In a head-and-shoulders composition, raise the camera above the center of the face to help elongate the nose, narrow the chin, reduce fullness of the jaws, or broaden the forehead. Lower the camera below the center if you wish to shorten the nose, reduce the width and height of the forehead, or accentuate the chin and neck.

Camera at eye level

3½ inches below **7 inches below** **10 inches below** **14 inches below**

3½ inches above **7 inches above** **10 inches above** **14 inches above**

Corrective Techniques

The successful portrait photographer realizes that his principal aim is to obtain characteristic likenesses of his subjects. At the same time, however, he must temper reality with flattery. The portraitist does this by combining judicious posing, suitable lighting, and appropriate choice of camera angle. Although each situation in portraiture is different from all the others, the following suggestions for corrective treatment are generally accepted. Use them judiciously and be careful of over enthusiasm.

Difficulty	Suggested Treatment	Difficulty	Suggested Treatment
Prominent forehead	Tilt chin upward Lower camera position	Double chin	Raise main light Tilt chin upward Use high camera position
Long nose	Tilt chin upward Face directly toward lens Lower main light Lower camera position	Facial defects	Keep on shadow side
		Prominent ears	Hide far ear behind head Keep near ear in shadow Consider profile view
Narrow chin	Tilt chin upward		
Baldness	Lower camera position Screen to shield head Use no hair light Blend top of head with background tone	Glasses	Tilt downward by elevating bows slightly Adjust fill light laterally Have subject raise or lower chin slightly Use small light source and etch reflection from negative
Angular nose	Minimize effect by turning face toward lens	Deep-set eyes	Lower main light Use lower lighting ratio
Broad face	Raise camera position Use short lighting Turn face to three-quarter position	Protruding eyes	Have subject look downward
		Heavy-set figure	Use short lighting Use low-key lighting Use dark clothing Vignette shoulders and body Blend body with background tone
Narrow face	Lower main light Use broad lighting		
Wrinkled face	Use diffuse lighting Lower main light Use three-quarter pose		

Modern Makeup for Portraiture

By Rosa Russell

Over the last decade or so, the techniques for photographic portrait makeup, as well as those for television and even the stage, have undergone great changes. Greasepaint is no longer in general use; pancake makeup is largely a thing of the past. The trend today is toward a natural, translucent look and the best made-up face is agreed to be a face that does not look made up at all. For photographic portrait makeup, only a few products are necessary in most cases, and the kinds of products you will need are widely available in cosmetic departments serving the general public. Purchase hypo-allergenic products when possible and inquire about allergic sensitivities before applying makeup to your subject.

Study the Face: The objective of good makeup is to show the person. The first step requires standing back and studying the face. Note the good points that you will want to accentuate as well as the defects that you may be able to remedy or minimize. The general principle to keep in mind is that lightness accentuates and darkness makes features appear to recede.

The Skin: Evaluate the condition of the subject's skin. Your first job, before applying any makeup, is to make the skin look healthy, pliable, and elastic. Skin condition can obviously vary with age; it can also vary with life-style. For example, an 18-year-old leading an outdoor life in the sun may well have the dry skin and fine lines that might generally be seen in older persons.

Moisturizer: A good-quality moisturizer is called for whenever the skin appears dry, wrinkled, or sunburned. Many makeup artists always use a moisturizer prior to applying foundation, to enhance the elasticity of the skin surface.

Foundation: You will need three colors of foundation. The basic color should closely match the natural color of the model's skin. A lighter color and a darker color will be needed when the makeup artist begins to contour the model's face. As mentioned before, the lighter foundation is used where features need to be brought out, such as with dark circles under the eyes; the darker foundation will be used to minimize a feature — for example, a dark tone can soften the look of a strong jaw or prominent cheekbones.

Powder: The trend today is almost exclusively to use a very fine, sheer, translucent powder. Powder is applied by dipping a makeup brush into the powder, shaking off the excess, and making several very light applications over the foundation. Powder helps set the foundation and absorbs any excess moisture from the skin. It should never be darker in tone than the foundation. The effect you want to achieve is to retain the natural look of the skin through the foundation and the powder. Some makeup artists place a pair of razor blades in the loose powder and shake the container vigorously before beginning to apply the powder. This will keep the powder light and aerated.

Eye Makeup: Makeup artists have very individualistic approaches to their job, so there is no right approach to the art. Depending upon your evaluation of the face and the effect you seek, eyeliner may be applied to the upper eyelash and you may wish to line the

underlash of the eye as well. If you line the underlash be sure to soften the line with a cotton swab to achieve a natural look. The eyeliner is not softened on the top lash. The eye may be winged with the same liner to achieve a wide-eyed look. Consider using two colors if, in your judgment, the person can wear this effect.

Next, eye shadow is put on over the eye. Apply the shadow out and up to the crease of the eyes. You may wing it lightly from the corner toward the hairline, if you wish. The effect should be very faded and muted.

Mascara is applied after the eye shadow to both the upper and lower lashes. Most makeup artists avoid the mascara with fibers and opt for a plain mascara in cake form. This is applied in sheer, gossamer layers, in four or five light applications, and then brushed out in order to separate the lashes and present a soft and natural look.

Shaping of the eyebrow is usually done with an eyebrow pencil. Dark brown or even blue is often preferred over black because black gives a rather hard line. Black eyebrows, even in subjects with jet black hair, photograph with a harsh look. Following the pencil on the eyebrows, a stiff toothbrush should be used to soften the brows and leave a subtle, natural look.

Modern Makeup for Portraiture

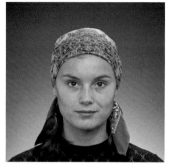

1 Clean face plus moisturizer

2 Base applied— showing bottle

3 Eye whitener— under eyes

4 Eye whitener— blended

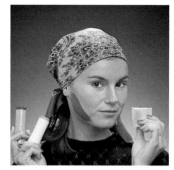

5 Shadow and highlighter

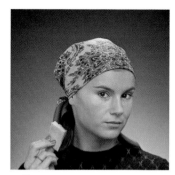

6 Shadow and highlighter—blended

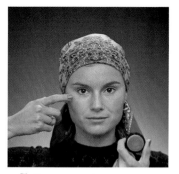

7 Cream rouge

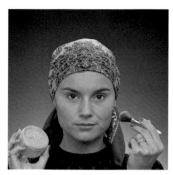

8 Face powdered

Contouring the Face: Professionals differ as to when contouring of the face should be done in the process of making up for the camera. The general rule is that with liquid or cream, contouring is done before the translucent powder is applied. With powder rouge, contouring is usually done after the translucent powder has been applied. Contouring, of course, is an art in itself. Noses and jaw lines are frequently contoured by makeup artists. The idea, again, is that light colors emphasize while dark colors reduce a feature's prominence. It is generally agreed that many women use too much makeup in attempting to contour their faces; they fail to blend the makeup carefully to eliminate harsh lines. Blending and allowing the natural skin to reveal itself are paramount. The intent is to show the person and to make the viewer, or camera, unaware of the makeup.

Lip Makeup: Lips are most often started by outlining—shaping and contouring them with a lip liner or eyebrow pencil. Then the outline is filled in with lipstick, lightly applied with a lip brush. Applying lipstick directly from the tube results in a very heavy look. Lip gloss or super-shine lipsticks are seldom used by professionals in portrait photography. Plain petroleum jelly stays in place better, is more natural-looking, and lasts longer under photographic lights.

9 Eye liner—upper and lower—sharp

10 Eye liner—upper sharp, lower feathered

11 Eye lid shadow and highlighter

12 Eyebrow pencil and brush

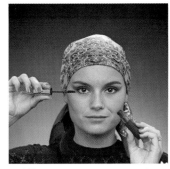

13 Mascara—upper and lower lashes

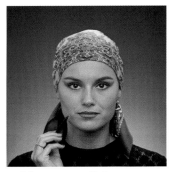

14 Lips—outlining

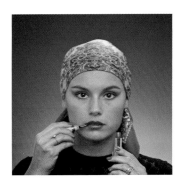

15 Lips—filling

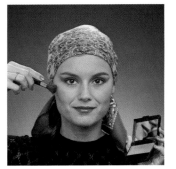

16 Blush powder added

17 Hair styled, makeup complete

18 Makeup complete, costume changed

Modern Makeup for Portraiture

Makeup for Men

A skillful hand is required for the artful application of makeup for men. Never lose or try to camouflage the strong masculine appearance of the male face. For instance, don't soften the strong jaw or the prominent nose. However, you may want to enhance or give the illusion of enlarged eyes and a defined lip line. Skin density and condition have to be considered. The greatest difficulty will arise in minimizing a dark beard, or five o'clock shadow. Often a quick shave will do wonders. Unattractive blemishes and dark circles under the eyes also pose problems, as well as ruddy or sallow complexions. So, before starting your makeup, analyze the face and determine what corrective measures will have to be taken.

The male face is often dry, leathery and

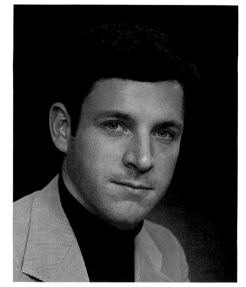

3 Clean Face

1 Clean Face

2 Face Powder Added

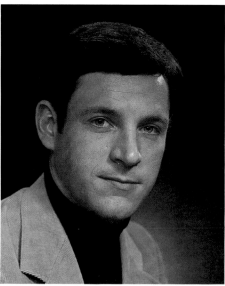

4 Foundation Added

lacking in elasticity due to overexposure to the elements. When you are confronted with this condition, be sure to apply a moisturizer to the face and neck area. Allow the moisturizer to be absorbed by the skin for a few moments, then blot with a tissue to remove any excess moisture. The skin will now appear more pliable and elastic and will look younger and healthier.

To correct a ruddy complexion, apply foundation over the entire face. This foundation tone should be one shade lighter than the skin's natural coloring. Be sure to blend carefully around the hairline, jaw line, and nostrils to avoid a made-up look. Choose a foundation tone one shade darker than the natural color to correct a sallow complexion.

Dark circles or puffiness under the eyes can be minimized by applying nude or porcelain foundation or by using one of the many white erase-sticks. Blending is the secret here for a professional looking job.

Unattractive blemishes and moles can be minimized by applying the same nude foundation or light-colored erase-stick over the blemish or mole. Blend the makeup out from the center and leave the heaviest coverage over the mole or blemish.

After the necessary corrective makeup has been applied, a sheer translucent face powder in a light shade is brushed over the entire face. This will smooth out imperfections in skin color and absorb any excess oil or moisture. To camouflage a heavy beard, brush in loose, dark, face powder.

Petroleum jelly, applied to the eyebrows and eyelashes, will help shape the eyebrow and make the lashes more noticeable. Pencil the eyes lightly with a soft gray color along the top and bottom lash line to make the eyes appear larger.

Make use of the petroleum jelly or lip balm for dry, chapped lips. Round out, lengthen, or define the lips with a soft, brown pencil, and then smudge the line to obtain a natural look.

Continue to control excess oil or moisture during the shooting session with loose translucent face powder in a light shade.

For men's fashion photography, the best effect may be had with a foundation applied to the entire face, followed by a light application of powder. The powder should be brushed out of the man's eyebrows, and a small amount of petroleum jelly used on the eyelashes and lips. Hair spray is, of course, useful in making-up men as well as women. In both cases, avoid the made-up look.

A Makeup Kit: The trend in makeup is to use a minimum of products. Foundation is used sparingly, only a little contour color is applied. These products plus a lip pencil can change a whole look. Many things can be done with only one or two items. A good supply of makeup might consist of the following items:

> Moisturizer
> Foundation — three colors
> Blush
> Gloss
> Mascara
> Eyeliner and eyebrow pencils
> Loose, translucent powder
> Sponges for applying foundation
> Cleanser
> Toner
> A set of good-quality makeup brushes

As a rule, models should be made up while wearing a robe. They are more comfortable, and spills are less of a problem. After the makeup is complete, drape face and hair in a scarf and slip on the clothing. While on the set, shine is controlled with application of loose powder. The powder must be continually fluffed and aerated in its container. Compressed powder should not be used.

It bears repeating that today's look in makeup is sheer and see-through. Application of makeup should not begin before you have made a thorough study of the person's face. Help and advice is usually available at most good cosmetic counters.

Obtaining Makeup Supplies and Advice

Great varieties of makeup used for photography can be found at any good makeup counter. The people attending the counter are often experts in makeup application and will be happy to help you select the products you may need. In many cases, these professionals will do the makeup for you, if you bring your model along. Additionally, many of them can be retained to come to the studio in their free hours.

Group portraiture is a very big subject and an important one if you are interested in the photography of people. More than the individual subject, the group offers the photographer experiences in recording relationships as well as people. By simply adding one or more people to a portrait, the dynamic and decorative impact of the photograph is changed considerably.

On Group Portraiture

By David B. LaClaire

Photographing groups offers the professional two great opportunities: a chance to sharpen one's understanding of human interaction and a profitable marketplace that has been greatly neglected.

Thirty to 50 percent of my work has been with family groups for most of the 29 years I have been in the portrait business. I enjoy group photography and welcome this opportunity to share with the reader some of my procedures, techniques, and insights. They are offered with the hope that each one will discover his own style and his own objectives.

Objectives

There are all kinds of group portraits; each has its special objective. The study of group portraiture can be approached as the study of portraiture by objectives—yours and your client's.

Knowing what your client has in mind is the first step. The rest of your efforts will be to reconcile his wishes with your professional objectives and the possible world. If your client's objectives have been fully thought out

"This is not the average home. It was designed for this family's particular tastes and interests, and they were personally involved in the construction. They wanted a portrait that captured some of the feeling of the architecture and design. By placing them across the room, the concept of space is well illustrated. More personal portraits were made with the family around the piano."

and you ignore them, you can make a thing of beauty and still have an unhappy client. On the other hand, most clients have not thought it out very well and will need your help. For instance, the married children of an older couple will want to surprise their parents with a portrait of their families together. This really means making two or more family groups simultaneously on a sheet of film. It really doesn't make sense unless the grandparents are included. When they are, you have a single, logical family. Once this is pointed out, it is easily understood and, even though it means giving up the surprise, your guidance will be appreciated. In other words, it is necessary to guide your clients to a set of objectives on which you both agree.

Let's assume your client wants a family portrait to be hung in his living room. A series of questions arises: Where is the portrait to be made: in the studio, home, or outdoors? If at home, whose home and what room? If outdoors, what is the appropriate setting? If in the studio, how can it be made appropriate for a particular group? What clothing is appropriate? How formal or informal? How many people? What ages are they? How many subgroups? Are pets appropriate? What colors will work best? If it is outdoors, what time of day? The answers will require the cooperation of your client as well as your understanding and experience. These questions on preplanning are so important that it almost seems that the actual photographic session is just a simple extension of the answers to these questions. It is not unlike building a building. With a good set of plans, the building will succeed. The building plans come from very clear statements about objectives.

To summarize: Group portraiture should start with clear statements of objectives—

yours and your client's. From these objectives, plans can be made by seeking answers to many questions such as those I have used for illustration. Your success will come as you become sensitive to the appropriate questions for each assignment.

Elements: With these preliminary matters well in mind, your knowledge and experience come into prominence. It is out of your background that the important questions are formed. You will find that these questions are shaped around four major elements of group

portraiture. So, let's analyze them; they can be divided into the following categories:

The light qualities	***The people***
Perspective	***The location***

In order to achieve a truly decorative portrait, consideration of each of these is important. Keep in mind as I discuss them that there is great potential for variety within each of these elements. As I describe those things that I emphasize, try to establish your own values, for you may feel you would place

"This portrait illustrates the importance of balancing the subject and interior lighting with the light coming through the windows. The space is not closed in and, with some imagination, the illumination can be perceived to come from yet another window on the sunny side of the house."

David B. LaClaire

On Group Portraiture

more importance on different qualities. You will be working with the same four major categories, however.

The people: Working with people is the most challenging and least controllable feature of group portraiture. Development of your own style or personality will determine your success. The psychology of the situation and the individual personalities of your subjects are of tremendous importance. So, gearing yourself to the attitudes and feelings of your subjects is the challenge against which your professional personality will develop. Other qualities of the subjects are important as well: size, sex, age, clothing, coloring, etc. Physical attributes will require as much awareness as the psychological. It is your job to weave all of these qualities together. Remember, each individual in the group has his own special characteristics. He relates to other members of the group in his own special way. Since you can't analyze each person, it is best to simply look for clues as you go along. A successful family group portrait will physically illustrate how the family members feel about each other at that time. For instance, I recently photographed a couple and their three daughters. The oldest daughter had been away at school for two years and they were all feeling (jestfully) the broken ties. We arranged that daughter on the other side of a fence from the rest of the family. The design kept her as part of the family, but the separating symbol was there.

The location: In order to achieve a decorative portrait, appropriate locations should be selected for their compositional qualities as well as for their appropriateness to the interpretation. A sense of the abstract qualities of line, mass, and color is essential. As your

"Working in this sunlit situation, squinting eyes can ruin the portrait objective. By facing the subjects into a dark area (wooded or shrubbed) so that they are not facing glare from sand and sky, and by turning them away from the sun, the problem is kept to a minimum. A flash fill is sometimes needed. Although early morning and late afternoon are usually preferred for outdoor work, midday, in some situations, has a luminous quality with which some very special work can be done."

David LaClaire works with large-format cameras and transparency materials in a great percent of his exclusive portraiture. The beautiful dye transfer prints that are the final product of his photography are produced in his own laboratory under his direct supervision and are unexcelled in photographic quality.

David B. LaClaire

awareness increases, your appreciation of 20th-century art will increase. It doesn't matter whether you are indoors, outdoors, at home, in an office, or in the woods, your awareness of these abstract qualities and how they affect your subjects will require some basic understanding.

The source of that understanding seems to be somewhat instinctive. I'm not sure that it can be taught. What is generally desired is a combination of shapes within which the group can be organized with appropriate emphasis. When the eye enters the completed portrait and travels through the image logically, in an organized way, without interruption, the location is providing compositional support.

Of course, this must be achieved within logical interpretative and decorative bounds. It is at this point that whimsy and humor can be enjoyably employed. Contrasting dress with background, using patterns or designs to make the viewer "discover" the content, or doing the unexpected for fun can be consistent both decoratively and interpretatively.

David B. LaClaire

"This is another three-generation family group. Studio Light *Magazine published a portrait of the first two generations of this family in 1952. After constructing the composition and making a series of conventional portraits, I suggested that they take a few minutes to talk together. Although most people prefer full-face photographs of their own families, this gives a good feeling of intimacy."*

On Group Portraiture

The light qualities: I have deliberately put light into its own category rather than including it with location. They are inseparable, of course! The difference is that artificial illumination makes light a working variable; the trick in my work is to use artificial light so that the viewer would not guess that it had been done.

Light is part of what makes a location work. Unfortunately, there are not many locations where the natural light treats the arrangement in the desired way at the time of the sitting with enough impact to affect the film appropriately. The problem with artificial illumination is that it complicates the mechanics of constructing a portrait. However, without it, much of what I do would be impossible to accomplish.

My usual assortment of electronic flash units includes one 18,000 W.S. (watt second) pack with four lights, two 200 W.S. packs with four lights and miscellaneous adaptors to the lights. I also carry a 200 W.S. battery pack with two lights.

Before using the flash units, the location must be studied to determine how much, if any, of the natural light can be used. Also, the strobes should be introduced so that their light appears to be natural. Finally, they must do their job of creating the feeling of structure in the subject matter.

It is difficult and even dangerous to teach lighting on the basis of a formula. The study of how the direction of light affects subjects is important. Once this is understood, decisions about lighting can best be made from the concepts as they apply to the location rather than selection of a formula.

Perspective: The lens choice for a group photograph is also a function of the camera format used. In other words, choice of lenses is determined by what reality is on either side of it. For my work, a 5 x 7-inch camera is used most often, although I find 35 mm to be useful for some things. I prefer the perspective controls of a view camera and the image quality of the larger format. With my 5 x 7, I use lenses from 4 inches to 20 inches in length. Most frequently the 7½-inch and the 12-inch lenses are used. The choice of lens may be determined by space limitations indoors or by background relationships outdoors. The constraint of depth of field is often a deciding factor. Sometimes it is just how the situation feels to me personally.

In any event, it is a mistake to leave the choice of perspectives out of your repertoire for both practical and aesthetic reasons. I find the flexibility that several lenses provide is most helpful and a natural part of the process of selecting a location.

Exposed on KODAK EKTACHROME Professional Film (Daylight), 5 x 7 inch. Finished as dye transfer prints and photo-mechanical reproduction.

"Carl Forslund & Sons is one of America's fine Early American furniture manufacturers and retailers. Every two or three years they have a new family portrait made to hang in their family gallery in the store and for reproduction in their catalog. Their family pride is a very real thing and for almost fifty years our portraits have been an expression of that pride.

"Note how easily the three sons with their own families can be identified."

David B. LaClaire

This is one of the most animated family portraits that we have seen. It is to the credit of the photographer that the animation has been allowed to remain unarranged. Three umbrellas from the right, one of which was bounced from the wall and ceiling, and a background spotlight are the lighting arrangement that captured the rich flesh tones of this happy family.

Preplanning and Preparation

After you have gathered enough information to have established your objectives and reviewed the elements of the group as they apply to these objectives, your plan begins to take shape, not in detail but in a general way. Now it's time to prepare your subjects, yourself, and your staff of assistants, if you are not working alone.

Guidelines for subjects: There is usually one person through whom you must work with the subjects prior to the actual time of the sitting. In a family, it is usually the mother. Whoever it is, I usually request of them that two or three clothing alternatives for each individual be available at the time of the sitting and that these alternatives be appropriate for the display objective. I use the term "degree of formality or informality" that is consistent with their life-style and the formality of the room in which the portrait will be hung. The final choice is made at the time of the sitting.

Another important part of subject preparation is that they be rested. This is particularly true for children but also of adults. This factor suggests morning as the best time for the appointment. If the sitting is outdoors, early morning may be best. Sometimes late afternoon is the best time for the location. When this is true, children and even adults should nap.

Cocktails can be a problem, particularly late in the day. Alcohol and portraiture don't mix. One person with a drink can ruin the whole thing. We specify in advance that no one is to have an alcoholic drink before the sitting is completed. Occasionally, I will have a drink with them afterward, so that they

Theo Germann

71

Takashi Ogishima

"*A Gala Day for Children of Three, Five, and Seven Years of Age: In this commemoration family portrait of a mother with her seven-year-old daughter and five- and three-year old sons, I had the girl stand straight beside her mother to emphasize her growth in comparison with the mother's stature. A toy flower cart was used to complete the composition.*

"*I used six electronic flash units, including two umbrellas, totaling 700 watt-seconds to provide the same light ratio and balance to the four people.*"

Monte Zucker

"*This family wanted an informal grouping in the area of their home, showing the casual atmosphere in which they live. The clothing was carefully chosen so that the children could show their individuality, yet so their bodies would blend visually and their faces would all stand out.*

"*Each person was allowed to sit basically as he or she normally wished, with slight refinements to space the faces evenly. The diagonal line of the steps was used for the basic composition and the height of the various steps was used to place the heads in triangular compositions.*"

will know I am not making judgments about their life-style.

Details about personal care and accessories are mentioned at this time. New hairstyles or glasses that are unfamiliar should be avoided. Meaningful jewelry and other memorabilia that can be introduced logically to support the format of the portrait should be considered. Using children's toys or sports equipment, picnic baskets and blankets should be considered for their appropriateness. Getting your subjects involved by considering these things in advance can bring out some helpful ideas. On the other hand, it is wise to let them know that you will use such things at your discretion.

Self-preparation: It is equally important to prepare yourself. Besides reviewing equipment, materials, and client preparation, your attitude and concentration are important. By reviewing the primary features of each assignment during the period just prior to meeting the subjects, you can prevent oversights and work more smoothly with your subjects. Review who the subjects are, their names, ages, sizes, and anything else you know about them. Consider your objectives.

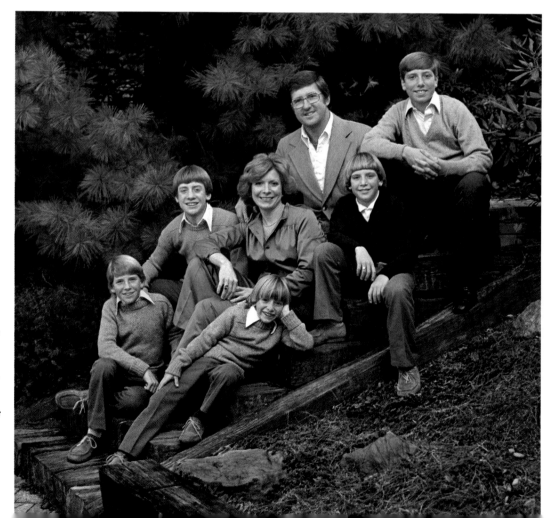

Make sure you have the right equipment. Review the procedures that you will follow when you or they arrive.

Staff preparation: If you work with assistants, their preparation is just as important as your own. Planning the special things that they will be required to do, and reviewing them just prior to the appointment, is an important extension of your personal preparation. Also, they should have information about the subjects. They should review the usual things that you expect from them. Having them help scan the group for problems with clothing, hair, and other things can save retouching. An assistant can review your equipment during the sitting to make sure that all is functioning properly. How they work with you will determine how sensitive they are to the group. Review it with them and ask them to go over it in their own minds. You can't anticipate everything when you are working with people but it helps to try.

On assignment: Everything up to this point has been preparation but there are still a lot of decisions to make and a lot to learn about your subjects. Four major considerations must be tended to before you are ready to make the first exposure:

a. Final clothing selection.

b. Final location selection.

c. Direction for equipment choice and placement.

d. Arranging the group.

Your procedures when you are working on location are more complicated than studio work, but it is necessary to consider all these same factors. When on location, it is helpful to work with an assistant, but not essential.

If we are working in a home or an unfamiliar location, my first effort is to review possible places in which a composition can be worked out, but no decision is made. Next, if we are in a home or office, I ask to see where the portrait will probably be displayed. Then I am ready for step No. 1, to review clothing for a final selection.

Several things are happening during these first steps. I'm getting a sense of the situation from colors, to the tastes of the subjects, to the mood and the lighting opportunities and requirements. When we begin to review clothing, I can make judgments about the colors as they will be in the composition and when they are on display.

Probably the most important information I look for during this ritual is the psychology or mind-set of the individuals to be in the group: who is eager to please; who is truculent; who needs special attention; who should be left alone? The questions that come to mind during this period help to provide answers to problems in composing the portrait. By working with each individual and at the same time remembering the overall needs of the composition, you can give your subjects the opportunity to become comfortable with you while you learn about them.

I can't overemphasize the importance of this selection process.

Clothing: Having gotten an idea of where you might work, clothing selection can be made with this in mind. Sometimes colors that harmonize are best. Other times color contrast seems appropriate. Frequently, I will find two or more possible combinations and will ask the subjects to determine their preference. Clothing colors should work well with the location in which the photographs are to be made and also with the location in which the portrait is to hang. Clothing color is also important in the arrangement of the group. (Your composition will be influenced by the effect of clothing color on the viewer's eye movements. The same is true of brightness as well.)

Remember, you have discussed the importance of the "degree of formality." Your final selection should follow the same guidelines. Make sure that no one is unreasonably out of context as to formality, season, or color. Occasionally, your choice will be a deduction.

Clothing selection is one of those things that sounds very complicated because it is very difficult to describe in detail. Your basic understanding of colors and how they work together—in other words, your good taste—must be relied upon.

While the selection process has been under way, my equipment has been brought to the general location. If the subjects begin dressing immediately, they will be ready before I am. Therefore, I suggest that they wait until I give them notice to dress.

We are getting closer, but still there are decisions. Now that the clothing is chosen, I have to make the final decision about the location of the portrait sitting.

Location: This decision is usually made while reviewing the clothing. After reviewing locations earlier, the subsequent decisions are made concurrently as the clothing, location, and lighting take shape in my mind.

Every assignment works a little differently. The important thing to know is that these things will come together for you out of your awareness of their importance.

Some of the specifics that I look for indoors

On Group Portraiture

are simplicity of background, textures that will give the portrait softness, furniture that can be adapted to the people, and light source that can be implied in the portrait.

There is some conflict between the need for simplicity and the need to illustrate the home setting. The photographs can become too severe if you have just a plain white wall for a background or worse when the plain wall has small rectangular objects hanging from it.

This typifies the photographer's dilemma. You can't reconstruct or redesign a family's surroundings according to your own tastes. You must decide on the most favorable compromise: in this case, to leave the small objects, remove them, or replace them with something from another location.

There is another aspect to consider in selecting a location that relates to the psychology of viewing. That is space limitations. As you view a photograph of a wall, your mind is limited by that wall. Putting people in front of the wall doesn't alter the psychological limit unless you put them some distance from the wall—but still, the wall is a barrier. Put a window in the wall and the viewer's mind can reach through the window. Properly placed, the window can be used as an implied light source. When successfully done, there is a self-contained logic to the situation you're recording.

This is most easily seen indoors but the same applies outdoors. Light through a tunnel draws the mind to it. Paths can be walked on with the mind. The decorative quality of your work will be greatly enhanced if you can weave these qualities into your composition.

There is a paradox to all of this, of course. There are groups that can be successfully photographed against a wall—and the wall limitation becomes part of the interpretation. This is the kind of thing to have fun with—but not out of context.

Equipment: As your decisions about clothing and location develop, it becomes necessary to decide where and how to use lights (if at all), where to place the camera, and the lens to be used. As soon as it is convenient, your assistant should begin this work.

Frequently, it will be necessary to move furniture out of the way. The final choice of furnishing (either indoors or out) takes place along with this equipment setup. As you can see, I have divided the sitting procedures into four categories. However, when you're on the sitting, they are not entirely sequential. Keep this in mind as I discuss equipment.

Lighting, as I have indicated, should not reveal itself. This is, of course, an impossibility under many circumstances, but still a worthy objective. You have already selected your location, based to some extent on the opportunities for lighting. Now your assessment should be to determine how much of the natural light should be used and whether it is to be incorporated as directional light or as fill light. When this is decided, you can begin to apply your strobes or whatever you use to the scene. I prefer strobes—but that is another subject.

Al Gilbert

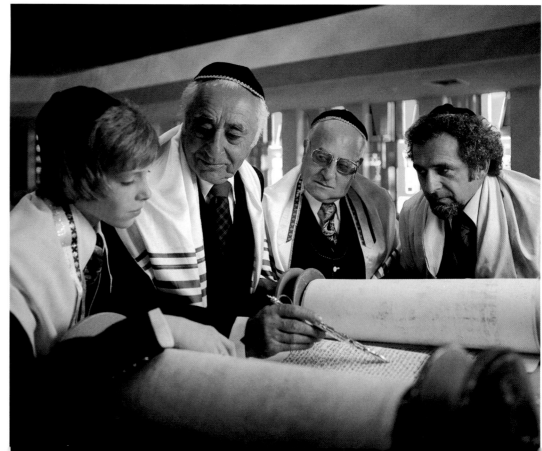

Bar Mitzvah: **Three generations attend an important moment.**
Natural light from the right, tungsten light from above and the left, and the multiple hues from the stained-glass windows in the background make this an unusual negative to print, to say the least. However, the final result is pleasing and impressive.

Just as you decided about the natural light, the decision about the directional or "fill" use of your strobe can be made. The objective is to achieve a maximum feeling of depth and form in the subjects and, at the same time, match the scale of illumination throughout the subject to the film scale and the print scale. I feel that the use of your directional or main light is best when it approximates the same broad and short lighting (45 degrees) used in individual portraiture. This must be done logically and consistently with the natural light implied in the composition. If there is a window, can it be used as an implied light source? If the room has windows that are not in the composition but do establish the prevailing light in the room, will the portrait look more natural if you imply that the light is from these unseen sources? If you are outdoors, time of day, direction of natural illumination, and intensity of natural illumination all present problems that can be solved only on the job but consistent with the same concepts used indoors.

Rather than using lighting diagrams for instruction, a discussion of light measurement may be more to the point. It is important to balance light sources and light ratios as well as to determine the appropriate exposure. Your f-stop is determined by the intensity of your strobes and your shutter speed is then balanced at that f-stop to give you the right exposure for the natural light.

Structuring the Sitting

Now, before the subjects are ready, the scene is prepared as much as possible. You have arranged your lights and structured the sitting, pretty much at the same time. Let's talk about structuring a little.

By structuring the sitting I mean anticipat-ing your composition of the subjects and arranging furniture, or whatever is to be used (rocks, logs, trees for outdoors) the way you would hope it will all come together. This is simply a guess — albeit an educated one. You know something about each person in the group; you have anticipated the subgroups and the personality combinations that seem to be significant; you know the important points to emphasize, and you know how to create emphasis; so there is a lot of information that you have that can go into this structuring process.

The more completely and accurately this work can be done before the subjects enter the scene, the easier it will be to hold the group's attention and to make a pleasant experience out of the occasion for them.

The time you have been building toward is at hand, but before we begin work on that final phase, let's review the things that have been important in getting us to that point. They outline this way:

The objective – theirs and yours

Elements of the group
The people
The location
The appropriate light qualities
The camera and lens perspective

Preplanning and preparation
Guidelines for the subjects
Personal preparation
Staff preparation

Preparations on the assignment
Clothing
Location
Equipment and direction
Structuring the scene

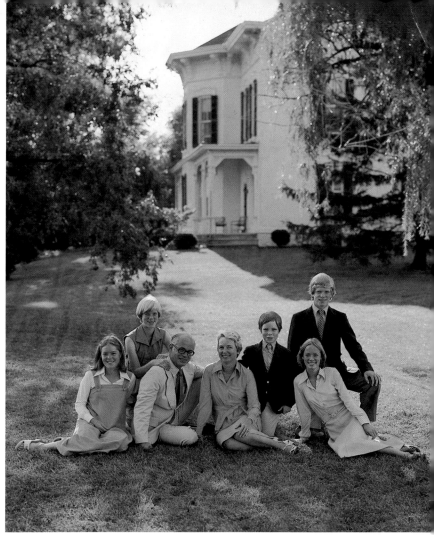

A Family Portrait on Location at Home: *"The simplicity of this portrait hides the amount of work and time required to make it.*

"At a preliminary discussion with the clients, it was determined that the portrait should be made at their home in the country (with a complete array of horses, duck, geese, and other assorted animals). These were eventually used in individual portraits, which we feel are a very important part of a family portrait. In the pre-sitting discussion, the direction of the sun in relation to the home was determined, along with the general layout of trees, shrubs, etc. Normally on location assignments, we go to the location at the same time of day as the appointment to examine the layout and lighting, and to certify that the location is an appropriate one for the size of the group and what we are trying to say in the portrait. In this case, the home was an integral part of the family since they had moved there from the city some years ago to learn about nature in a more ideal farm setting. (I might add that the father is an executive in a steel company.)

"No additional lighting was required because of the large expanse of open sky. The backlighting provides a beautiful change from the usual flat frontal lighting found in most outdoor portraits."

Jerzi Jakacki

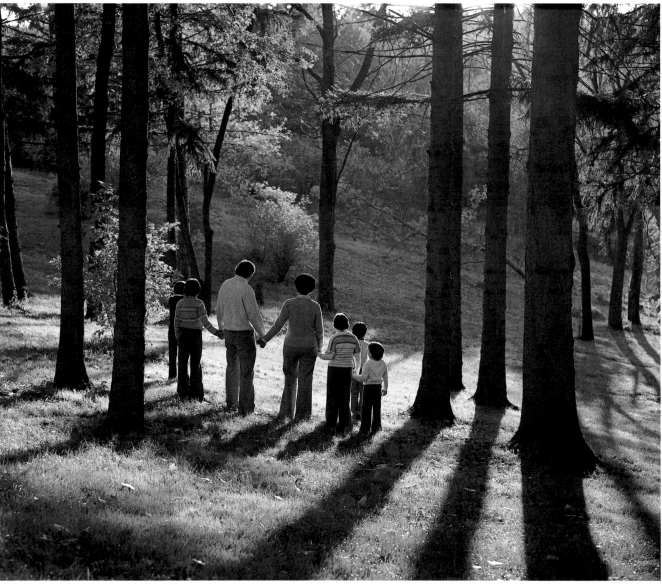

And finally, here is a charming family portrait containing all of the elements of the previous photographs in this section, minus one—faces. Photographer Jerzi Jakacki of the Focal Point Studio, Farmington, Michigan, tried "one more" exposure and came up with a salable idea.

"Focal Point Studio is merchandising the idea of decorating with photographic art by personalizing their product with the participation of the purchaser.
"Photographed at sunset with a Mamiya RB-67 camera, KODAK VERICOLOR II Professional Film, Type S, 120, a 127 mm lens at 1/30 second at an f-stop of 5.6."

Pulling It All Together and Making Exposures

With all in readiness, your subjects enter. You're about to have a delightful experience or a disaster. I'm going to tell you exactly how I set the stage with the subjects and why. If you have an instinctive sense of balance or abstraction of design and can convert my guidelines to your own use, you should have no trouble with any group, no matter how big it is.

I insist that everyone be present before beginning. Then I request their attention and proceed to give them a brief but tremendously important explanation of what we are doing, how we are going to do it, and why (if asked). It goes something like this.

"I would like to tell you a little about what we are going to do now that you are all ready. We have tried to anticipate an arrangement. It usually takes a little time to put it together and sometimes we guess wrong. This arrangement is very important. What you should know is that, if I am not asking you to do something, whatever you are doing is okay and you don't have to worry about a thing. The one thing I would like to know from each of you is any discomfort or unnatural feeling you get from the instructions I give you. If you have any questions, feel free to ask at any time. It's that simple and, once we complete the composition, it won't take long to make the photograph."

You should develop your own way of handling this situation. The most important thing to remember is that every member of the group has feelings, fears, and anxieties. It is your job to put them at ease. The best way is to let them know what you are going to do and what you expect of them.

Now you are ready to complete your com-

position. If it is a two-generation group, I start with the mother or father. Which I start with will depend on the seating arrangement I have anticipated and the function I have chosen for the clothing selected for them. In any event, the two of them are arranged almost as if they were to be photographed without their children.

Then the children are introduced — let me try a stream-of-consciousness description: small child, mother's lap — put in last; oldest daughter, father's favorite — arrange by him, dress chosen for this position; son, mother's favorite; son, rebel — position with back to group; nine- and ten-year-olds don't like each other — have them hold hands (might not work — but try it); 12-year-old son on floor with dog; and so forth. Everyone fits into a slot based on family ties, their size, and the clothing selected for them.

The same procedure is used in three- or four-generation groups. The only difference is that each two-generation group should be arranged to reflect their relationship within the big group. It's more complicated, but your subjects will tolerate an amazing amount of manipulation if you are deliberate in your effort to solve each problem as it arises. I hope these illustrations will reflect how such relationships can be handled because it is too complicated to describe in detail in a few paragraphs.

After the group is arranged, final checks of your lighting, exposure, and camera position, lens, and focus are required. When all is ready, you're on!

There are many possibilities in directing a group to get an appropriate and concerted response. I frequently ask that the adults direct their attention to me when I request it and let them know it's all right to look around when I'm not by the camera prepared to make exposures. It is not easy for some people to respond to this request. Mothers want to check everyone over as though it were their responsibility. Others want to look at whom you may be speaking to or about. I just proceed to make a few exposures and joke about what they are doing, as I work. Eventually they will correct their behavior with no unusual discomfort.

When this is accomplished, you can carefully select individuals to talk with — teens about girlfriends — fathers about teens — kids about pets — things you may have picked up during the preliminaries. The whole family will react to silly questions and the responses you may get. There is some kind of timing that goes with this that your instincts will respond to by making the exposure. Don't try to wait until everyone is perfect — you can't watch them all at the same time. It's that action on your part bringing a response on theirs that must be depended upon. No one can tell you how to do it. It is a skill to develop through experience.

Animals can be helpful. You can talk with them and take the pressure off the rest of the family. If you have experience in the handling of small children in the studio, you may be able to work with them as though no one else is present, also taking the others' minds off themselves.

If all goes well, you can take the time to make small changes and improvements as you go along. If you are satisfied, you can try a second or third complete change in composition — sometimes including a clothing change. In homes where you have to struggle to find even one composition, don't worry about finding a second arrangement within the same setting.

Another way to break things up a little is to ask your subjects to stay where they are but take a break from the session by talking with each other. It's hard to be candid with a group, but once the group is structured, some interesting things can happen by directing their attention away from you.

My usual sitting will consume 16 exposures. I have found that fewer can be inadequate and more is hard for most groups to tolerate. Your job is to get just one outstanding portrait. By developing the right rhythms with all the things we have discussed, you should have few problems in achieving that specific result.

Family is still important; it is not obsolete; it is probably the most desired and desirable aspect of life in America. It has been abused by many and its dissolution has been sensationalized in the media. I think the bottom line is that all any of us have to care about is people and the people we know and care about become our family. Families are helped to perceive themselves through photographs. That makes the role of the portrait photographer very important. When he is skilled, he becomes a unique cultural asset to his community.

Finally, there are many other skills that follow the making of the photograph. Reviewing the transparencies and helping your clients select and use your work in the most appropriate way, good finishing, letting your clients know what to expect from your work, guiding their investment and planning for the years ahead, planning the corporate use of group portraits, delivery and final display: these are all important to your professional role. Be thoughtful and helpful all the way and you'll have a good time.

Good luck!

"What's so hard about taking pictures of people outdoors? Everybody does it. Why pay a professional photographer for pictures that require no lights, no studio, no set?" These are the questions that may come to the minds of some prospective customers if you suggest this type of portraiture to them. Actually, they are good questions. With automation built into modern snapshot cameras and the exposure latitude of today's amateur films, technically excellent amateur photos are the rule rather than the exception in the many millions of photographs produced by camera hobbyists and casual picture-takers everywhere. The professional portrait photographer must be prepared to demonstrate some very good answers in order to survive.

Outdoor Portraiture

Outdoor Fill-Lighting

Here are some excellent examples of successful outdoor portraiture. Notice that the sun is usually backlighting or sidelighting the subject, with flash units or reflectors adding the proper fill illumination. Outdoor portrait lighting, necessarily, is quite fundamental.

Success in this type of work lies in selecting a relevant background, setting a mood by pose or activity, and finally, directing viewer attention by selective focus, print manipulation, and cropping.

Because of an increasing awareness and appreciation of nature, the field of outdoor portraiture is growing phenomenally. It will continue to do so, for the field is not yet crowded with experts. Take every opportunity to engage in this pleasant endeavor but remember that it requires all of the sensitivity and professional know-how of studio portrait work, plus a good deal of special lighting technique.

Peder Austrud

Happiness Is To Be Outdoors in the Summer: This beautiful child portrait was made on an overcast day. The 150 mm lens was used wide open, and the resulting shallow depth of field directs attention to the subject. A black vignetter on the lens further subdues the busy surround to focus on the happy child.

Soft morning fog diffuses the natural light into the illumination associated with studio fashion photography. Notice how the brilliant background colors are muted and how the boys' figures dominate the composition.

Hubert Oger

Taken on the Island of Corsica, using a light diffusion filter to soften the brilliant Mediterranean sunlight. Perhaps because of the diffusion, or the reflection of light from the surround, the midday, overhead sun casts shadows that are much less opaque than usual. The rule that forbids portraits in the midday sun is therefore broken without consequence.

When you are working outdoors in an open-shade situation, the light is omnidirectional and can produce an unpleasantly low light ratio.

"The subject was placed in open shade, against a background of trees, facing the direction of greatest light. To increase the ratio of light on her face, two black umbrellas were used —one overhead and slightly behind her, and one in front of her face. These umbrellas, plus the hat, produced a directional lighting and picked up the rim light which highlighted her profile. Thus, a subtractive measure of light was employed."

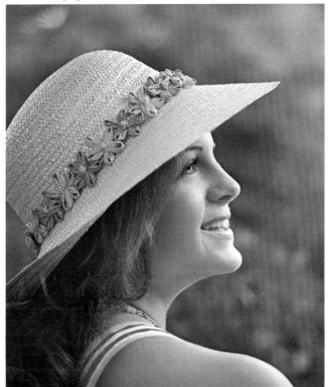

Don Blair

Outdoor Portraiture

Outdoor Fill-Lighting

One of the qualities that separates the professional portrait from the snapshot is the proper maintenance of a reasonable light ratio. This is particularly true in outdoor portraiture, where the main light is quite unadjustable.

By reasonable light ratio we mean something between 1 to 2 and 1 to 6; that is, where the light on the shadow side is from ½ to ⅙ that on the highlight side, as measured by a reflection light meter.

There are two methods of providing the fill source with which to maintain this lighting ratio: The first and simplest is to use large reflectors. You can make adequate flat reflectors from 20 x 24-inch double-weight mounting board, with one side white and the other covered with matte aluminum foil that has been crumpled and reflattened. Don't use mirror-finished foil, as it produces specular reflections and hot-spots. Use the matte aluminum side when you need a fairly strong fill and the white side for a soft glow. Regardless of the reflector, base your exposure on the fill-light intensity. The other method of fill

Al Gilbert

Late afternoon sunlight streaming through this unique port highlighted the subject's hair. A small electronic flash unit to the left of the camera acted as the main light, and a small reflector to the right filled the shadows. The balance between daylight and artificial illumination was controlled by the shutter speed.

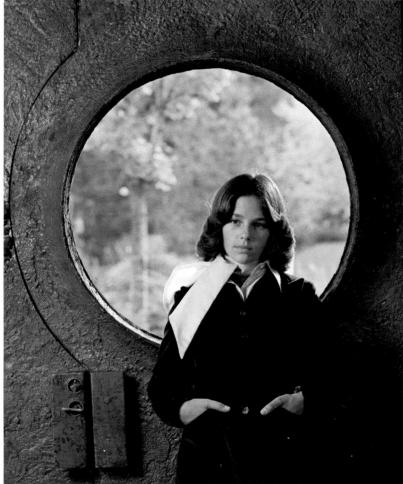

Steven Goldman

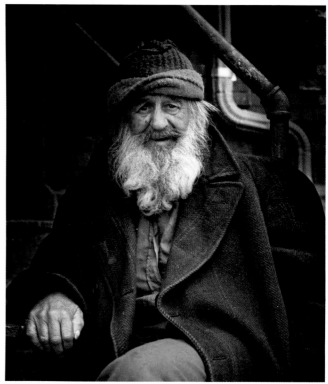

Character studies, such as this, are an important part of portraiture. Often they are the product of studio lighting and makeup box. Here is an honest, daylight portrait of a strong individualist. Only the background has been changed — by darkening in printing.

lighting is to use electronic flash. Compute the exposure as follows:

● Place your subject with his back or side to the sun.

● Check on the table below to find the distance range from subject to flash for proper fill-in. Read to the right on the BCPS rating line for your electronic flash unit. You will get full fill (1 to 2 light ratio) when the subject is at the near distances, average fill (1 to 3 light ratio) when the subject is at the middle distances, and slight fill (1 to 6 light ratio) when the subject is at the far distances in the table.

● Adjust your camera shutter to the speed recommended for the subject distance/light ratio that you select from the table. Then, using an exposure meter, determine the correct lens opening to be used for your front-lighted subject in daylight at the shutter speed selected.

● Set your lens and expose the picture.

This table works for any film because it is based on the ratio of flash to sunlight, not on the film speed. Note: This table has been computed for use with bright sunlight.

Subject Distances for Fill-In Flash with Electronic Flash
(Distance in Feet)

Output of Unit BCPS	Shutter Speed with X Synchronization*				
	1/25-1/30	1/50-1/60	1/100-1/125	1/200-1/250	1/400-1/500
350	1½-2-3½	2-3-4½	3-4-7	3½-5-8	4½-6-10
500	2-3-4	2½-3½-5½	3½-5-8	4-5½-9	5½-8-13
700	2-3-4½	2½-3½-6	4-5½-9	4½-6-10	6½-9-15
1000	2½-3½-5½	3½-5-8	5-7-11	6-8-13	8-11-18
1400	3-4-7	4-5½-9	6-8-13	7-10-15	9-13-20
2000	3½-5-8	5-7-11	7-10-15	8-11-18	11-15-25
2800	4-5½-10	6-8-13	8-11-18	10-14-20	13-18-30
4000	5-7-11	7-10-15	10-14-20	12-17-25	15-21-35
5600	6-8-13	8-11-18	12-17-25	15-21-30	18-25-40
8000	7-10-15	10-14-20	15-21-30	17-24-40	20-28-50

*With focal-plane shutters, use the shutter speed that your camera manual recommends for electronic flash.

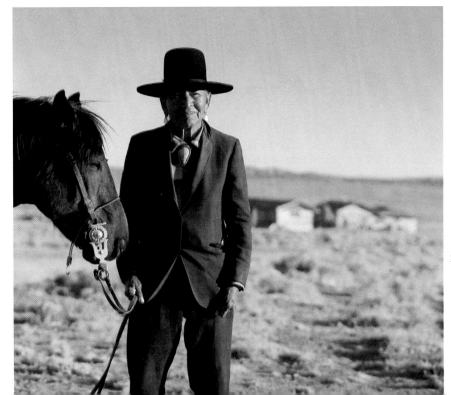

Ralph Cowan

This portrait of an elderly Indian gentleman and his horse, with his home in the prairie background, was made under an early morning sun. The setting is certainly the ultimate of "outdoors."

Outdoor Portraiture

An unusual location portrait. The background was chosen for its dramatic impact and for the combination of straight and curved lines.

"All of the straight lines were concentrated to a point in the circle suggested by the curved ancient tree trunk. To maintain the geometric feeling, the model was posed in a pyramid shape.
"The camera was a Mamiya RB-67 with a 127 mm lens. The film, KODAK VERICOLOR II Professional Film, Type S, 120."

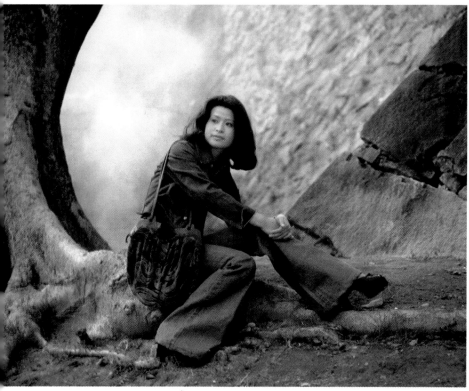

Saburo Masaki

Lady and Dog: The lush tropical growth of a Hawaiian garden makes a beautiful backdrop for a graceful full-length portrait.

"This is my wife Lurlene and her English Spaniel 'William,' crosslighted by the sun in a corner of our Garden Studio. The fill light was furnished by a 400 watt-second electronic flash directed into an umbrella at the left of the 8 x 10-inch view camera."

Damien Waring

Beauty and the Model A: *"This outdoor portrait was taken in Oregon during a seminar where I was an instructor. I wanted to combine the elements of good subject matter and a casual, natural attitude set in an interesting and beautiful background. Partly overcast skies provided lighting that reduced contrast, opened up the background and even gave a slight directional lighting from a 3/4 front direction."*

John Howell

The overcast sky and the bounce light from the snow-covered ground produce a perfect tent-lighting effect. The silhouetted window frame and shutters add a strong feeling of depth.

Preston Haskell

The beauty of relationships and activities photographed in a lovely natural setting places environmental portraits in the category of art rather than being just a record of faces and scenic landscape which, on second glance, is a personal portrait.

Instead of using umbrellas, reflectors, or flash-fill, which I find distracting, search for that soft, directional skylight that exists all around us if we know just where to look for it. Get out of direct, overhead sunshine and into the shade of branches. Work on the fringes of a woods where skylight, not bright sunlight coming in at an angle, forms your main light source. Light from directly overhead will cast shadows beneath the eyebrows of the subject, throwing the eyes into dark pockets.

Learn to watch the light shining on leaves. Sense where it is coming from and pose your subject accordingly. Don't be embarrassed to walk around your subject analyzing what the light is doing on the face. If perfect Rembrandt light is not there, a soft, rather flat light is acceptable in a color portrait of a group in a scenic style. Early-morning or late-afternoon light is by far the most pleasing. Backlight, that is so beautifully luminous, is found at these times.

Environmental Portraiture, Locations and Methods

By Linda Lapp

If at all possible, pick locations that do not have large spaces of open sky or all-over speckled light shining on leaves. A combination of textures and shades of green is pleasing. Flowers and complicated architecture are confusing. For full-length scenic portraits, try for a background that looks three-dimensional: dark edges around your subject, with a lighter, deeper space behind them—a woodland path for instance.

Throw the background out of focus using a large aperture, a longer focal-length lens, and maybe some type of diffusion device. You will avoid the necessity of burning-in the corners of your finished print by using a vignetter on the camera.

Formal gardens are not as nice as good overgrown woods. You need overhead cover from trees, as well as mid-height planting, low background plants, and some form of ground cover. Tree trunks in a lawn are symmetrical and confusing sticks.

Linda Lapp

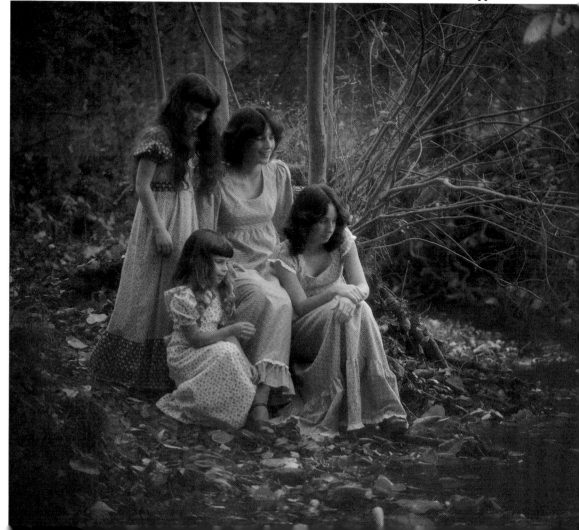

Four young ladies investigate the stream on Robin Wood Farm Studio. The natural light comes from the right and is modulated by reflections from the water. Notice how the long, pastel-colored dresses harmonize with the late-year foliage.

Use natural stumps, logs, knolls for posing. Wire together lengths of piling or logs cut at different heights for variation of head placement in groups or individuals. Poses, such as standing with one foot on a lower level, sitting on top with feet on a lower level, sitting on a lower level leaning back, or even sitting on the ground, resting against the pilings, will work well with this type of prop.

When working with groups, do three types of poses: the straight forward one looking at the camera, then some of the group involved with each other — maybe walking together, reading a book, whispering, etc, then others in which the subjects are involved with what is around them — children picking flowers, fishing, or inspecting a wonderful find.

Spontaneity is the prime concern when working with children. You have only seconds to anticipate the priceless moment. The secret is to be completely prepared before you let the action start. I usually have the Mamiya RB-67 SLR on a tripod, focused on the area onto which I will introduce the action. The exposure is set; then I bring the children into a rather loose, but pleasing arrangement and let the action happen. There is only one chance at each spontaneous reaction; one moment when the excitement reaches climax. Replays are not such fun anymore.

Have a stock of funny secrets you can whisper to one of the children. Tell him to wait until you are back at the camera; then let him tell the others.

Directing small children to read a book often results in stilted poses. Try using an old leather volume that photographs nicely. No child would want to read it — right? Inside the pages hide tiny surprises — maybe a pressed flower, bird feather, interesting leaf; now there is a reason to really concentrate on turning those pages.

Touching and loving — that's what we want to say in our family portraits. Don't let family group portraits express the nagging feeling that the people were uncomfortable with each other and the setting. The subjects must want to touch each other — to feel love — to feel relaxed — to enjoy the experience. It is up to you, the photographer, to create the mood.

The joy I find in being outdoors, easily strolling, using nature's light makes my subjects also totally at ease, almost oblivious of the camera. The resulting portraits are a pleasure to display and enjoy as very personal works of art.

Linda Lapp

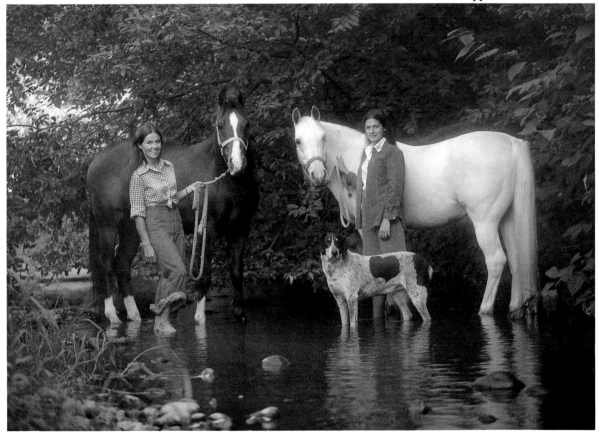

The different areas of the stream on the Farm provide widely varying backgrounds. Here two young ladies and their pets are reflected in a relatively still section. The natural skylight, reflecting from the water, makes a natural fill illumination. The texture of the summer leaves contrasts with the smooth areas of the horses' coats, and the low sun adds a touch of color to the background sky.

This composition is excellent as a single photograph, or can be split down the middle to make two complementary pictures.

Environmental Portraiture, Locations and Methods

Linda Lapp

This little babe-in-the-woods glows as if under a spotlight from her perch at the base of a huge old tree. The trunk and the overhead branches give direction to the light. Two field flowers accent the ground ivy. Another flower gives the subject a use for her hands and a reason to look delighted.

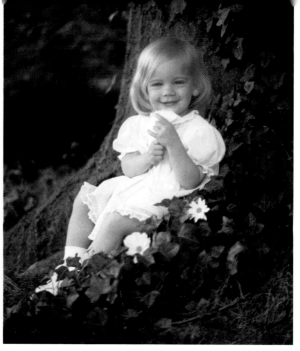

A strong equilateral triangular form contrasts with the undisciplined undergrowth of a favorite spot on the stream. Monochrome clothing, with just a touch of pattern, directs attention to the faces of the subjects.

Linda Lapp

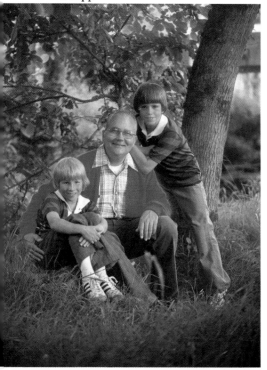

The boys and their grandfather are posed in shade at the edge of an open glade in the woods. The overhanging branches and heavy undergrowth to the left give a definite direction to the open skylight. The angular composition emphasizes the directional lighting.

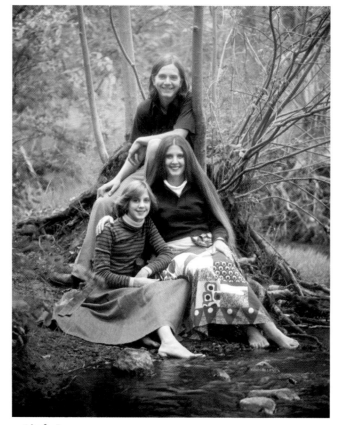

Linda Lapp

Linda Lapp

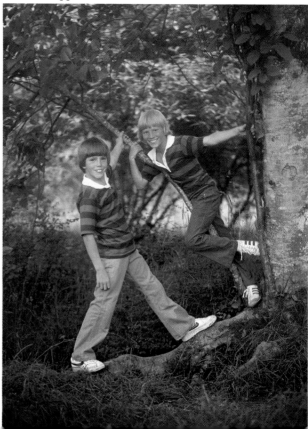

The white trunk and protruding roots of this old gray birch form a natural frame for the action of these two boys. Informal, monochromatic clothing does nothing to detract attention from their happy expressions. The background is broken by light from a distant meadow breaking through the summer foliage.

Black-and-White Portraiture — for Pleasure and Profit

For the past 15 years or more, color has dominated the portrait field. Naturally so, because the addition of color to the two-dimensional photographic image almost achieves the illusion of physical presence. After all, as we quoted Paul Anderson in the beginning of this book: "The fundamental purpose of portraiture is to furnish a complete and satisfactory likeness of the sitter."

However, during this time a small group of photographers have persisted in making outstanding portrait images in black-and-white. In fact, since the state of the science of photography has steadily advanced in quality in the black-and-white field as well as in the color field, more and more people are realizing the beauty of the monochromatic photograph, made with existing illumination.

In some instances, the black-and-white image becomes an abstraction — a balance of positive and negative forms and shapes on a plane. In other instances, the deletion of color simplifies the statement that the photographer is trying to make. Without the distrac-

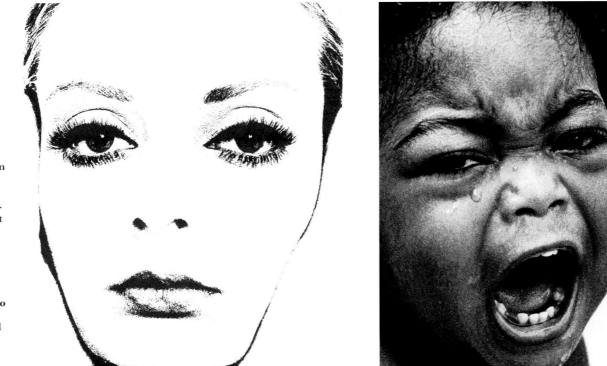

Ralph Cowan

This high-contrast, high-fashion portrait was first made on a continuous-tone film, then printed onto a Kodalith film material, retouched and reversed onto a second Kodalith film. The reduction of skin tones to pure white allows the features to be abstracted to almost pure design. However, those huge eyes retain all of their human allure.

Pat Lasco

Anger and frustration are no less potent when pictured in monochrome — in fact, the elimination of color makes this child's wrath even more forceful. Notice how the tears of rage stand out on the child's face. In color they would surely be less noticeable.

Ms Lasco finds great pleasure in teaching photography to children (older than this one) in Chicago's inner city when she is not busy doing commercial illustration with Ralph Cowan, Inc.

87

Black-and-White Portraiture — for Pleasure and Profit

tion of background color, the viewer's attention can concentrate on the subject and its action. The missing elements — color and third dimension — are almost automatically supplied by the viewer's imagination.

In a society where the faculties are deluged with ever-increasing amounts of sound, imagery, and color, it is an absolute pleasure to exercise the seldom needed or used sense of imagination. Perhaps this fact accounts for not only the increase in popularity of black-and-white photographs but also for the return of the dramatic radio program. It is fun

to become personally involved in something by having to supply an element of the whole with your intellect.

From the photographer's point of view, it is refreshing to return to basics. The pleasure of not only making the exposure, but of processing the film and making the print *to the quality of your own standards*, is quite satisfying. You will find that, no matter how many years it has been since you made a print, your printing skill and judgment will return in a very few minutes. And, depending upon the printability of your negatives, so

will your respect for the darkroom technician. In fact, nothing improves the quality of a photographer's work more than a few days (or evenings) in the print darkroom. Modern black-and-white photographic papers are responsive, and the new mechanized methods of paper processing have done away with that time-consuming drudgery.

Here are a few black-and-white photographs, very diverse in subject, but with two things in common: they were made with care and pleasure and they sold successfully.

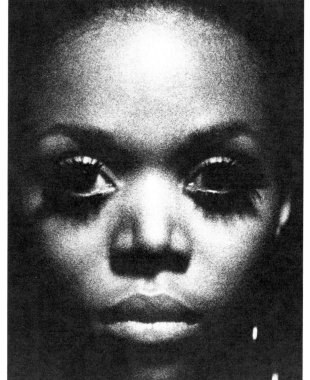

Ralph Cowan

An example of pure butterfly lighting. The symmetry and softness of the model's features lend themselves beautifully to the single-source overhead lighting. Notice that the light is brought forward just far enough to give a single catchlight in the huge dark eyes.

"Studio Portrait of Engineer B. Jobin: The main light was from a window to the left with fill from white paper. The camera was a Hasselblad with a Zeiss Sonnar 150 mm lens at f/5.6 and 1/8 sec, using KODAK TRI-X Pan Film, 120."

Rolfe Jeck

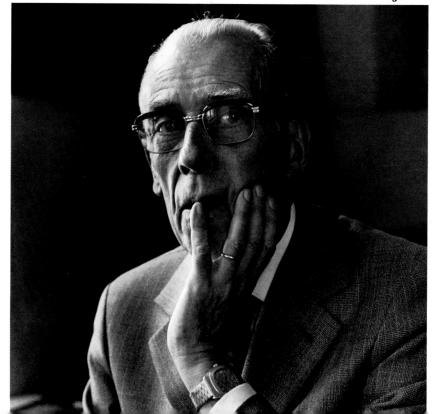

Ralph Cowan

The softening of the continuous
tones of this fashion photograph
by means of flare and diffusion
creates a mood of tranquility
and yet mystery. The eye
searches through the man-made
haze for a clear view of the
lovely model's features.
 An ideal illustration
technique for such illusionary
products as perfume or high-
couture fashion.

Black-and-White Portraiture—for Pleasure and Profit

The Story-Telling Portrait: Most portraits tell a story of some kind, if only to present a human being to the world. These black-and-white photographs, however, evoke a whole series of speculations. Here a robust little boy investigates the mysteries of the world of plumbing.

"This little fellow lives next door. It is fun to watch him grow and I find myself frequently finishing a roll of film on him that was started on a paying job. Young children, below 9 years of age, are easy to photograph and provide many, many images.

"The lighting was hard—bright sun, shining directly on the subject—but there was enough fill bouncing from adjacent light surfaces to permit normal development of the negative."

The Builders: *"I consider this a candid family portrait. The mother loves it, but the father does not. Frequently, people's reactions to a given print vary; what appeals to one, does not to another.*

"There are some truths about the family illustrated here. For instance, the mother (hands on hips) is not so involved in this project, but the father is. (Her specialty is helping to carve pumpkins.)

"I have found that the most successful photographs are those that are visually exciting (derived from technical competence) and that contain an element of meaning for the viewer. The technical competence is the sole responsibility of the photographer, but the meaning is often supplied by the subject.

"Lighting . . . difficult. Mostly skylight, with a little direct from low in the sky. This particular negative was exposed for less-than-normal development, but as soon as I finished the roll, I switched to normal exposure and development. Therefore, I consider the lighting 'normal,' but on the edge of 'contrasty.' If the sun had been higher in the sky and not behind the trees, so that more of the subject was directly lighted, the lighting would have been very contrasty and the development of the negatives severely reduced."

William Ziegler

William Ziegler

The Highwheeler: What a tale this photo tells of events previous and to come!

"This is not a candid portrait and was done 11 years ago. My boy, who is now 16, is the one wearing glasses in the picture. We have lost track of the other children, but Andy (glasses) loves to look at this photograph and think of his old friends. I remember that we all had fun taking the picture.

"The lighting is flat and mostly skylight with some fill from a nearby light-colored stucco wall which was in the direct sun. Had it not been for the house behind the boys, the lens flare would have been severe, for the camera was pointed directly toward the sun."

William Ziegler

Welcome, Child! "This is a photo of my mother holding her great-granddaughter. The child was born with a heart problem, which made for a lot of trauma in the family. She was 5 weeks old and very sick here. I did another series of portraits when she was older and much improved, but this first portrait is of great sentimental value.

"Lighting was flat and low-level. I boosted it, so as to enable hand-holding the camera, with 1000 watts pointed into an umbrella.

"There are many reasons for liking pictures. Probably the most important is that a photograph provides the viewer with a flood of memories. Photographs which show different generations are wonderful family records. When my reason for liking a picture matches that of the client, it most often is because the picture portrays a reality about a child as a parent sees it. In other words, the parent agrees with the statement contained in my photo. My personal reasons for liking a photo include technical things, such as ease of printing (which means a good negative), focus, contrast, and so on. Most of my work is in uncontrolled situations, so poor lighting, out-of-focus, and overenlargement are constant problems that are pleasing to overcome.

"I never take a photograph that is strongly posed. Probably that means that my rate of failure is higher than if I were to interject myself into the situation more. However, I think that my photos tend to be more 'honest' when I do not impose. This approach generally results in the best photographs coming from the best families. But far more important than candidness, this 'honest' approach seems to lead to knowing the family more intimately which, in turn, helps the photography. I explain to parents that I 'take' photographs, but that they 'make' them. The better they are at creating situations, the better the photographs will be. All I do is press the shutter. The success of my candid 'honest' approach depends upon the environment already established in the home and the extent to which the parents are involved with their children. The best homes provide the best pictures.

"To some degree, then, I am at the mercy of the people who hire me."

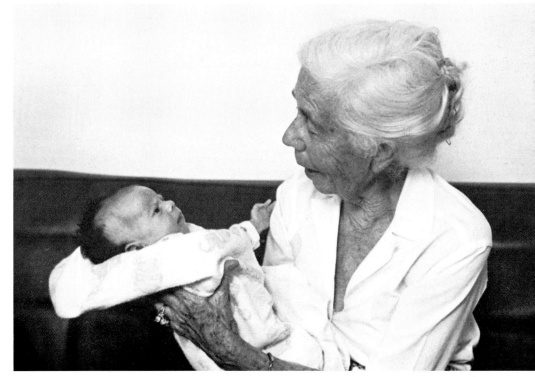

William Ziegler

91

The intimacy afforded by the tiny 35 mm camera often reveals a great deal about the photographer, as well as his subject. Surely this portrait of a famous old man was made with much honor, esteem, and love.

"Portrait of Josef Sudek, Prague, Czechoslovakia, 1973, with an Olympus 35 mm camera, a 100 mm lens at f/2.8 at 1/15 second, hand-held, on KODAK TRI-X Pan Film.

"Josef Sudek, who died in 1975, was the grand old man of Czech photography. His favorite cameras were a No. 1 KODAK PANORAM Camera, made about 1905, and a variety of large-format instruments. Despite the loss of an arm in World War I, he continued an active photographic career until weeks before his death at the age of 80. More than 10 books of his photographs have been published, and his work has been shown in museums and galleries all over the world.

"This photograph was made in his studio in Prague. The only light was from a single window."

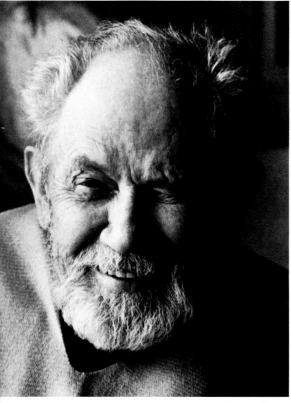

Phillip Condax

This enigmatic portrait of a young Indian girl in native costume was taken during a Fourth of July celebration in the Southwest. Riotous in the original color films, in black-and-white the intricate woven pattern does not overwhelm the expression in her eyes. Because of some skin defects, the print was made through a grain texture screen.

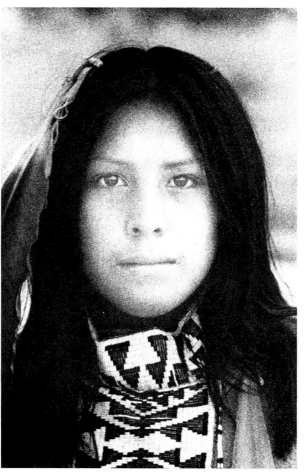

Ralph Cowan

Natural rim-light from a window highlights the lined face of this elderly citizen. A strong portrait, made more powerful by the use of black-and-white tones. The 35 mm camera, so easily and quickly available, makes this type of "candid" photography possible and the sensitivity of the photographer makes the photographs, themselves, almost alive.

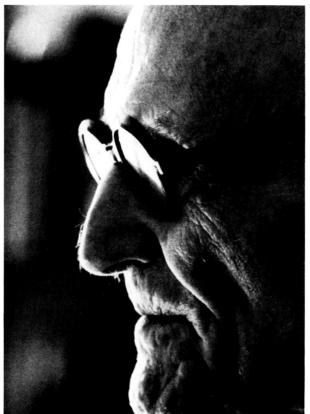

Pat Lasco

"A Lady of a Certain Age: This shot was taken with a Leica camera and a 50 mm lens on KODAK PLUS-X Pan Film (35 mm). It was processed in KODAK Developer D-76.

"The subject was on a train, and daylight was coming in through the side glass. I had no possibility of modifying the illumination or the background, so I performed the following steps in the lab after developing the film: Enlarged it on 30 x 40 cm film; reversed it by contacting it to another sheet of film; retouched it with red dye to balance the light on the face and the dress and to eliminate the background; printed it on paper and slightly retouched it with reducer. It portrays the subject in the manner that I wanted."

"Lute Player Hopkinson Smith During a Recording Session: The camera was a Leica with a Noctilex 50 mm lens at f/5.6 and 1/125 sec. Lighting was achieved with two 1000-watt Cramer lamps from the front and above. Film used was KODAK TRI-X Pan Professional Film 135."

Rolf Jeck

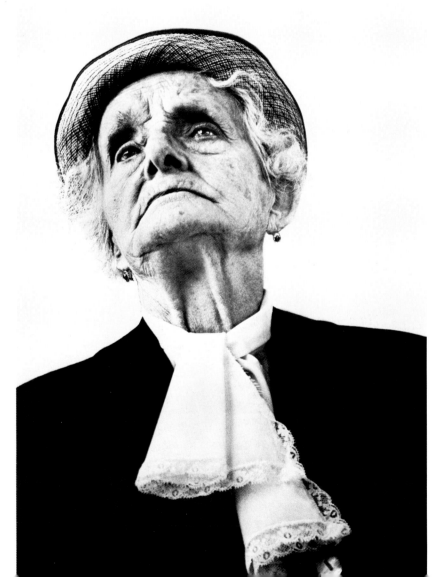

Jacques Degen

Black-and-White Portraiture — for Pleasure and Profit

Yasutaka Kajiyama

"Dr. Yamaguchi: This portrait was taken in the lobby of a maternity hospital, the wall of which is decorated with relief sculptures of mothers with their babies and children. I selected this background as most suitable for a portrait of Dr. Shigeru Yamaguchi, chief director of this hospital. The sculptures are not actually as large as they appear in the pictures; I had Dr. Yamaguchi sit in a child's rocking chair to position him as low as possible in the composition. Considering the psychological harmony between the subject and the background, I had him raise his hands in an attitude of prayer that I feel is not unnatural and is most significant. The most important thing in portraiture is the very living moment when a photographer can capture the deepest profundity of humanity in his subject. I waited for such a moment. The same thought links the benevolent doctor and the background. The prayer is the common wish of the doctor and this photographer.

"The lighting was with fluorescent illumination to which was added 6 tungsten floodlamps. The 4 x 5-inch view camera with a 180 mm lens at 1/8 sec. at f/11 1/2 exposed KODAK TRI-X Pan Film. The film was developed in KODAK Developer D-76 1:1 and printed on KODAK POLYCONTRAST Rapid Paper which was developed in KODAK DEKTOL Developer and toned in KODAK POLY-TONER."

Webster's New Collegiate Dictionary defines glamour as 1. a magic spell, 2. a romantic, exciting, often illusory attractiveness: alluring or fascinating personal attraction . . .

Many years ago, during the golden days of the motion picture industry (when Hollywood was spelled *HOLLYWOOD!*), there was a still-portrait photographer who was very great and very wise. He was credited with creating, single-handedly, the glamour-photography style of the '30s and '40s. He was much sought after by stars and starlets (not all young and not all beautiful) to be

Glamour
Portraiture

photographed by him alone, for to be so was to reach a certain pinnacle of fame in itself.

The photographer, although a master of portrait lighting (with the huge, hot tungsten spots, floods, and broads), attributed his success to his discovery of a secret liquid "essence of sex appeal," a small vial of which he always carried in his waistcoat pocket.

On the day of a glamour portrait sitting, when the subject had been made up, dressed, escorted to the specially built set, and posed; when the lights were positioned and the final adjustments to hair and garments had been made, the photographer would stride onto the set, the lights would go up and at that moment, with the little finger of his right hand, he would anoint his subject, on her eyelids, on the tip of her nose, and on the line of her upper lip with two drops of the pre-

cious secret essence. Instantly, she would be transformed! Her eyes would darken and widen. Her face would glow with radiance. A wave of magnetic allure would actually be felt by the assistants behind the camera. Of course, the sitting would be a success, the photograph a masterpiece, and perhaps a star would shine a little brighter and a little longer. The photographer would have earned his very considerable fee.

Once, after a rather busy period, the photographer noticed his supply of secret essence

Erich Muller-Grunitz

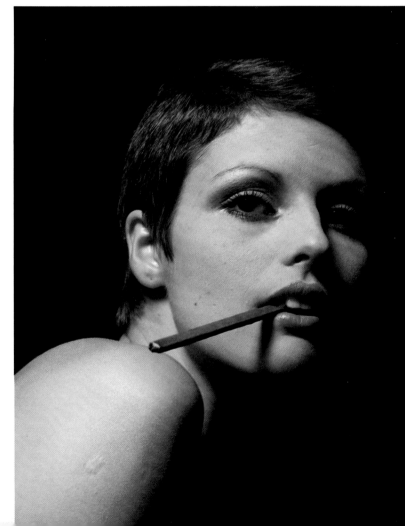

A resemblance to a famous actress and an incongruous prop can make a striking glamour portrait. A low angle and the complete lack of fill light lends a theatrical note.

Glamour
Portraiture

High-key fashion portraiture. A sun-dappled white wall substitutes for a studio paper background. Weak sunlight and ambient skylight combine to make any other illumination unnecessary. A low camera angle adds drama and a glamourous look.

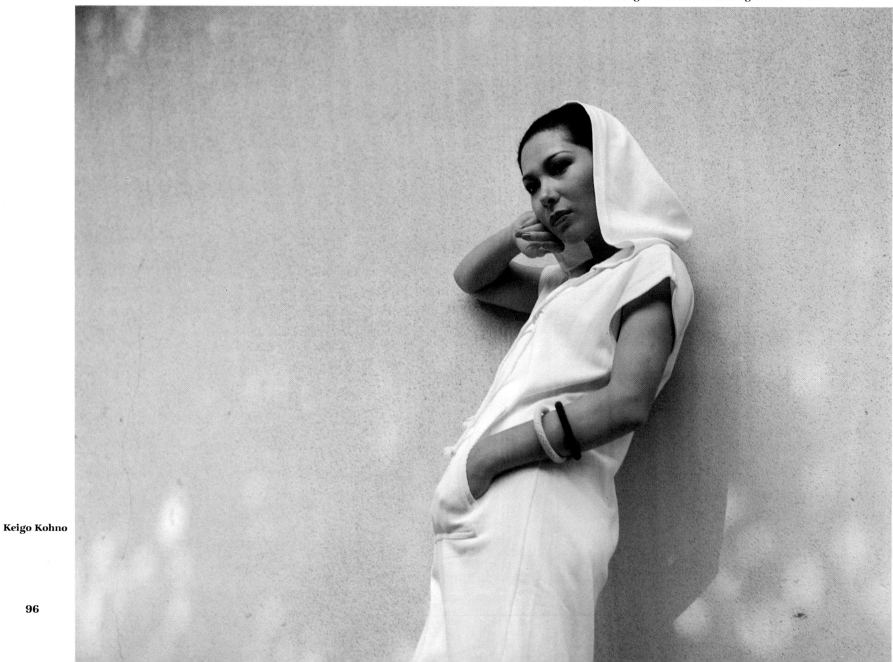

Keigo Kohno

was low, so he repaired to his office to replenish it. An assistant, on an errand, burst unannounced into the maestro's sanctum just in time to see him refilling his vial—from a bottle of *Johnson's Baby Oil!*

Of course, as a knowledgeable photographer, he was simply selectively increasing the highlight contrast in his picture. But because he knew his subjects, and realized that there is much more to being an actress than just memorizing lines, he made a ritual of adding the reflective oil, and activated the natural acting instincts of his subject with the mystery and the ceremony. This reaction gave him what he wanted, a glamour portrait of an instinctively beautiful woman.

There is nothing pertaining to a magic spell in these photographs, except, perhaps, the enchantment of light and the sorcery of the photographic process itself. Beautiful women, handsome men, a touch of humor, and the proper placement of lights make for attractive and glamorous portraits. The added ingredient is the ability of the subject to project a personality that is alluring.

Maybe there is a little magic here after all!

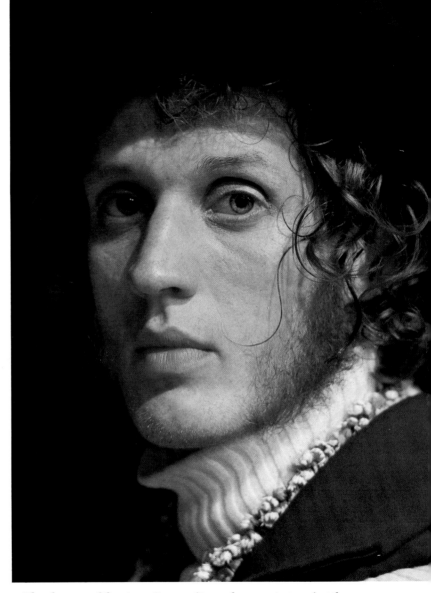

Max Koot

Hichiro Ouchi

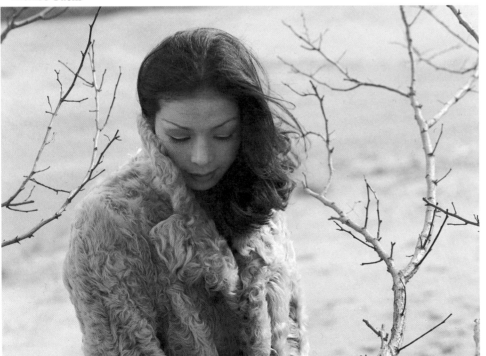

Backlighting by a cold winter sun and fill reflection from snow is the natural lighting for this lovely glamour portrait. The contrastingly angular lines formed by bare branches emphasize the softness of black hair, heart-shaped face, and fur coat.

The glamour of the stage. Because it was done on stage, using the typical, hard, high spotlighting of the theater, this portrait of a handsome young actor, in costume, has the same drama as a painting by an old Dutch master. In the language of the painter it is called "trapdoor" lighting; in photography, Rembrandt lighting.

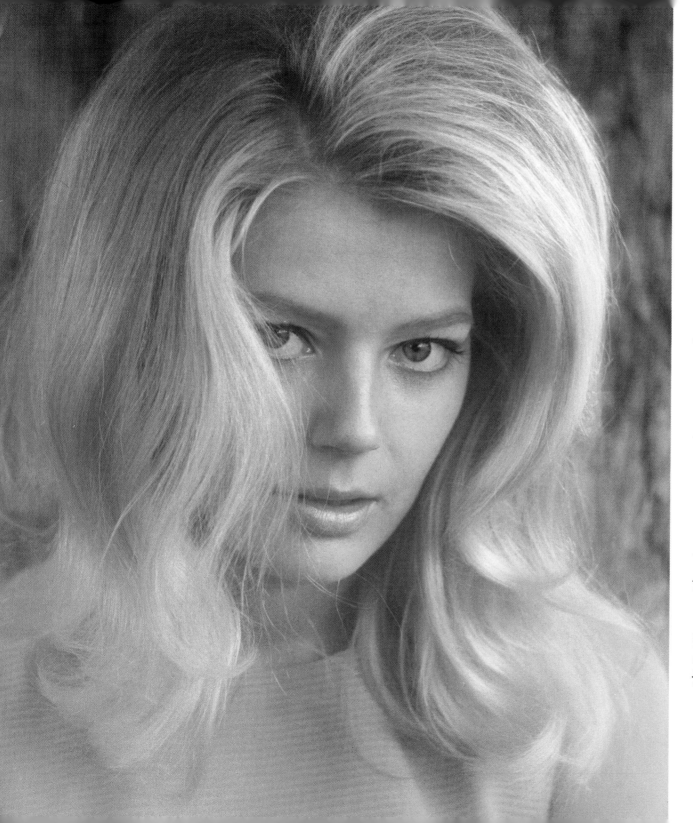

Christopher

Cathy: *"In open shade, against the huge trunk of an eucalyptus tree at the edge of a forest. I was being careful to have this most pleasant lighting directed toward her face and used no artificial lights or reflectors to change its quality. Concentrating on the subject, I recorded her reaction to me, the photographer, and to our topic of conversation.*

"Taken with a Hasselblad camera and a 250 mm lens on an extension tube — to show, close up, the expression in her eyes.

"What Is Important to Me in a Portrait, in Style, and in Working Method: I will sacrifice the beautiful, great quality that can be obtained from a 5 x 7-inch negative to be able to capture that very subtle, natural expression that appears on a face momentarily, just before it races away, to give room to the posed, sterile statue-like look to an otherwise living face as my subject becomes aware of the camera. If I am able to create an atmosphere in which my subject and I can communicate at a common level and I get him or her to be involved and to react, then I know that I have succeeded in capturing on film the person — manners, personality, and expression. This will give meaning to the portrait. It will be real and possess the spontaneity that gives life to a portrait.

"I cannot, I admit, do all this with a view camera and film holders. My subject follows my movements and paces her expressions so that, when I have no film in the camera, she is real. And always, without fail, when I am ready, she is READY, and starring as well. So I use a roll of film in a Hasselblad camera with a motor drive and a long cable release. I set all of the controls; then I work to create that magical moment when my subject feels (and I see her) most beautiful. Then all things click into place. With a photographer's sensitivity and sixth sense and the mobility provided by the equipment, I can recognize this climax and, since I am never out of film, I respond to the moment by simply pressing the button."

Glamour Portraiture

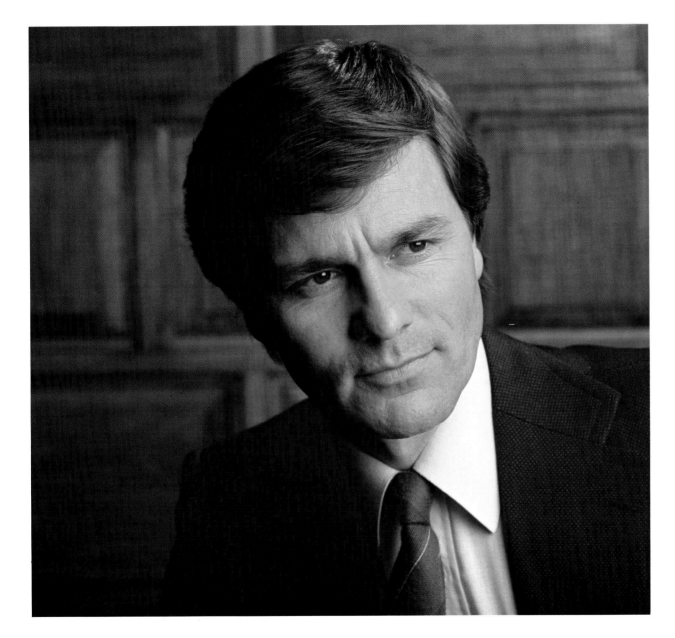

Ludwig Wunchmann

Neat, clean, fashionable, with harmonious color coordination. The wood panelling background is carefully out of focus and the center of attention is the intense expression of the subject. A very strong and glamourous portrait.

With a Mamiya 12B-67 camera, 180 mm lens at f/11, and 1/250 sec. Three Multiblitz electronic flash units furnish illumination.

Shades of the Sheik of Araby: Close cropping and a carefully coordinated color scheme give this fashion portrait a 1920's look. Note that there is not a single cool color in the photograph.

The unusual lighting consisted of a single electronic flashtube and a large diffusion panel to the left of the model. The model faced away from the light! The bounce from walls and ceiling provided enough fill light for printing quality.

Juan Villaplana

Glamour Portraiture

Alois Burger

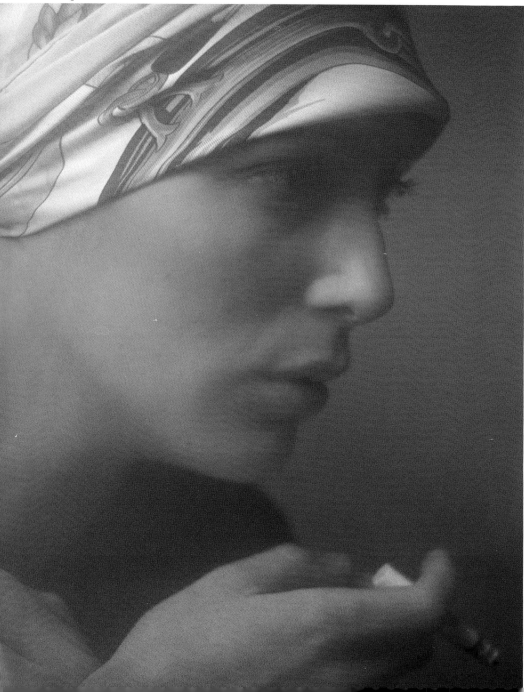

A modified butterfly lighting with adequate fill is most flattering for this young lady. The backlight that halos her hair actually becomes the main source of illumination. Notice how well this relatively flat facial illumination emphasizes the makeup and jewelry.

A Hasselblad EL camera with a 150 mm lens was used to expose KODAK EKTACHROME Film to two electronic flash units.

Beauty is universal when personified by youth and happiness and traditional culture.

Kiyoshi Watanabe

"Butterfly lighting was adopted for this woman's portrait. To make an accent, I used the top light to outline her head and shoulders. I had the subject take an S-shaped pose to express her femininity and released the shutter when her smile began to reflect the laughter in her heart.

"Based on the idea that a photograph is a kind of picture that should be drawn, I use nothing in the background other than cloth panels painted or originated by myself.

"The lighting angle should be kept at more than 50 degrees to the subject in order to give a dimension and to avoid mixing colors."　　**M. Takemori**

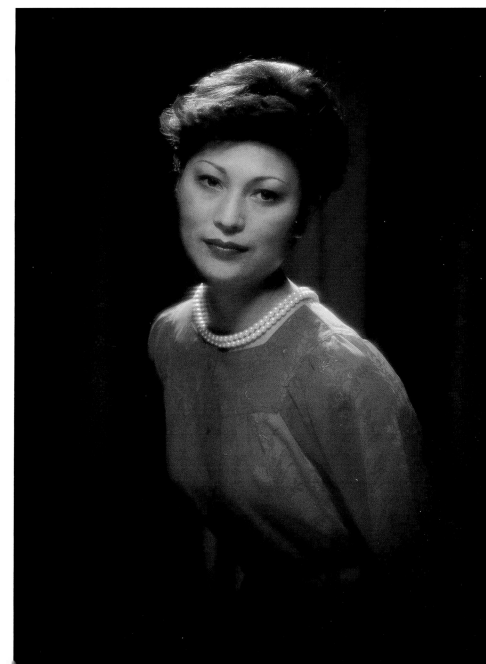

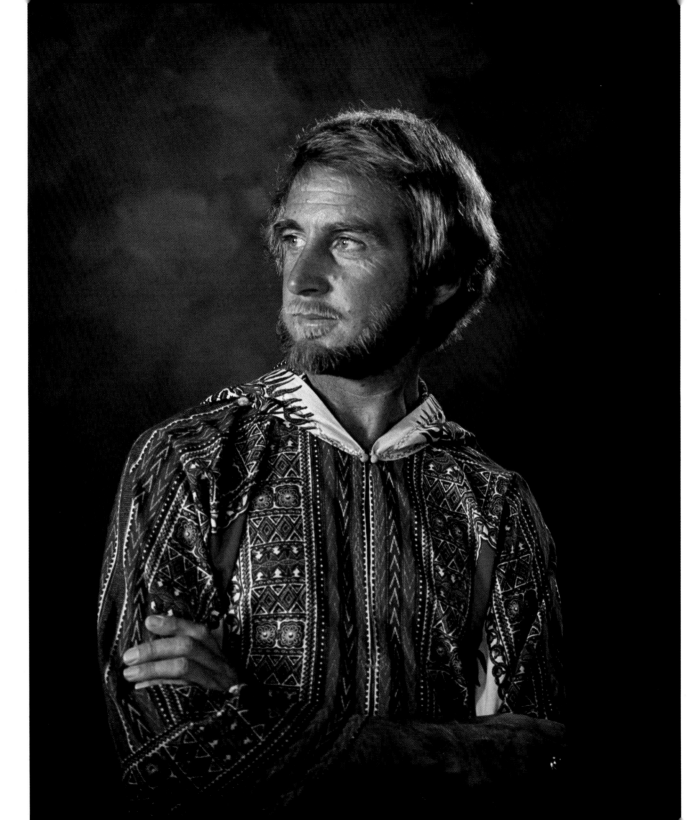

Glamour Portraiture

Ray Lester

Somehow reminiscent of the iron men who sailed the wooden ships of Elizábeth I's Royal Navy, this strong studio portrait is one of a series from which a companion print was awarded a merit by the Institute of Australian Photographers.

The flamboyant print of the subject's jacket does not detract from his fully lighted features. The painted cloud background, underlighted, adds contrast and drama.

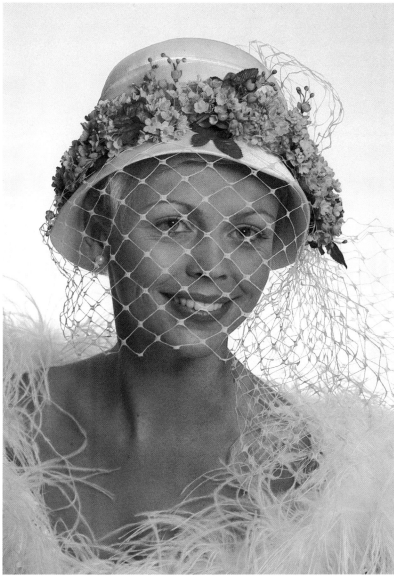

Sue's New Hat: Former Miss New Zealand, Sue
Nicholson, models a flowered hat and a feather boa.
This handsome glamour portrait adds props to
complement a beautiful face. Normal lighting has been
reinforced by a snooted spotlight kicker from the right
rear to emphasize the texture of the bonnet.

A very high-key, high-style spoof of the days gone by.
The lighting consists of three electronic flash units,
one on each side of the camera and another balancing
the background density to that of the white costume.

A very efficient lens shade is essential in this high-
flare situation.

Unusual Portrait Techniques and Presentations

You may not like the pictures in this chapter. You may like some of them and hate others. You may even wonder how a professional photographer could have the nerve to sell a bunch of darkroom tricks as a portrait. However, to again quote Leonardo da Vinci and Paul L. Anderson, "A portrait is descriptive of the sitter's personality." Here, certainly, are personality descriptions far beyond the scope of any conventional photograph. The devices used to produce these psychological descriptions are not new; double exposure, double printing, posterization, projection, texture screens—all are adapted from the discoveries made in the era of early black-and-white photography. These discoveries have simply been applied to modern color photography, but carefully and selectively applied

Double Exposure: Double-exposure portraits are being offered as a regular part of the portrait line of many professional studios.

Two separate photographic arrangements are used to produce the basic result. Care must be taken to fit one exposure into appropriate areas of the other. A clear acetate overlay on the camera's ground glass, marked with each composition, helps to prevent serious overlap of images. Exposures are either at the normal level (as was done here), or one exposure is subordinated to the other by stopping down the lens. The latter technique will make the resulting image less important in the final print. The one important factor to remember in planning double-exposure portraits is to maintain a black, or nearly black, background. Since a black background does not record on the film in the first exposure, there is unexposed emulsion remaining to record the second exposure.

Double-exposure techniques can become quite complex: witness the next few pages.

The camera used here is a Mamiya RB-67

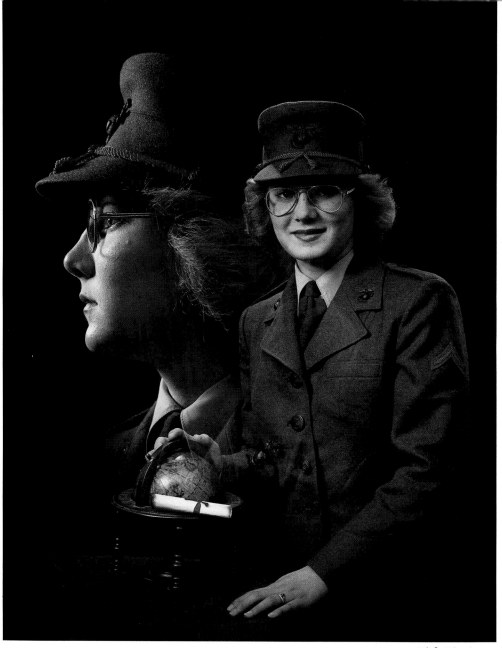

Rick Dinoian

with a 180 mm lens. Both exposures were 1/60 second at between f/8 and f/11. The film is KODAK VERICOLOR II Professional Film. Two electronic flash units on each side of the camera, hung from the ceiling, acted as fill at 200 watt-seconds each. The main light, which was moved for the second exposure, was diffused and at 100 watt-seconds. A 100 watt-second diffused hair light was on a boom.

by the photographer to characterize his sitter. These portraits are not haphazard pictures. They represent many hours of darkroom work and a complete knowledge of color theory as well as considerable insight into human nature. What is more, they sell!

Study these photographs and the methods that were used to accomplish them. Accept them or reject them as ideas for your own use as you see fit. Use them as a springboard for your own original concepts, too. (That goes for all the posing and lighting ideas throughout this book.) Then, as you produce your own portraits, try a new technique on an appropriate subject. If you succeed in doing something out of the ordinary in one of ten sittings, or one of 25 sittings, or even one of 100 sittings, you will be growing as a modern portrait photographer. As you grow artistically, so will your reputation and your business. And so will your pleasure in your chosen field of endeavor.

A double-exposure portrait does not necessarily have to be two different poses of the subject. Here the subject of the portrait and one of her works of art are superimposed in an unusual photograph.

"The photo was taken at the model's residence on her high school graduation day. The model has good skills in painting, and by making use of one of her 28 x 35 cm canvasses which simulated a human figure, a double exposure was made. The first exposure was made of the painting using only one sidelight at a lens setting of f/16. The second exposure was of the model against a black background, having previously marked the image size and location on the ground glass with a grease pencil. The illumination was made with only one direct sidelight, avoiding any light spill on the background. A Mamiya RB-67 camera and KODAK VERICOLOR II Professional Film, Type S, were used."

Riukichi Shibuya

"A Veteran Folksong Singer: This is a portrait of Hoyo Suzuki, a popular singer and teacher of Tsugaru Shamisen (a Japanese musical instrument) taken for a poster on the occasion of a recital.

"I have adopted the so-called montage style of photography (double exposure) for portraying such a dual-talented personage. The singing pose must be starkly reproduced in a realistic mood. Because a fantastic mood coupled with a rhythmic-melodic image is required for the Shamisen-playing image, the double exposure was made with an orange filter on the lighting source.

"The 4 x 5-inch Jinor camera with a 200 mm lens exposed KODAK EKTACHROME Film."

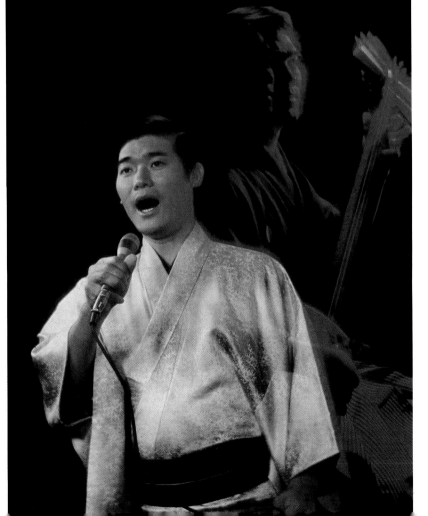

Juan Villaplana

One of the perverse laws of portrait photography is that if an exposure is ruined, it will be the best pose. Here, number 12 frame on the roll was somehow light-fogged. In an attempt to rescue the beautiful composition, the negative was printed in contact with a cracked-paint texture screen. The result is a modern Rubens. Sometimes darkroom techniques can be lifesavers—if you know how to use them.

Heavy texture has been added to this portrait of Luigia Aragno by means of a negative screen during the making of the print. The original photograph was a transparency and the print was produced on KODAK EKTACHROME Paper, Type 1993.

Alo Zanetta

Unusual Portrait Techniques and Presentations

This rule-breaking composition was accomplished by shooting directly into the setting sun and filling the resulting silhouette with a flash covered with a red filter.

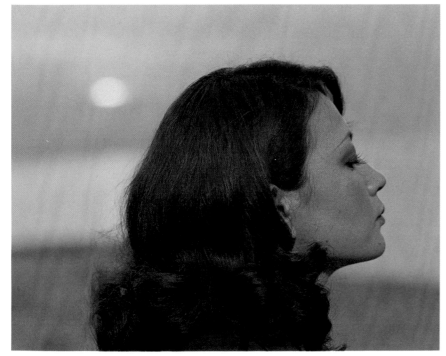

Hichiro Ouchi

This silhouette of bride and groom against a huge setting sun is the product of the color darkroom. Although the original *was* a silhouette, the strong orange color and the disk of the sun were added by color balance and dodging wand. Such enhancements add to sales.

Rocky Gunn

There's an advantage to creative photographs. They make us look freshly at something which is commonplace.

Actually, any photograph taken in a straightforward style is creative; it holds something still, makes it flat, and puts it into a rectangle, thus making us look at something freshly.

A Creative Approach

By Fred Burrell

But there are so many pictures like this that seem near substitutes for reality, we are not led to do more than look at the subject.

To show an emotional or intellectual aspect of a subject may require the extra effort of stylizing it, abstracting from it.

Perhaps a criterion for a creative photograph is that it shows something in an unusual way, while it does, indeed, show that something.

I have explored a wide variety of technical ways of making a photograph creative. I have tried to be a painter or illustrator, using light-sensitive materials. I've designed optics, worked with unusual materials, and mixed traditional methods, all toward the end of making something ordinary look fresh, new, and different.

I may take a sharp, conventionally lit black-and-white photograph of a head and

"This silhouetted figure with a spotlighted eye gained further drama by using a light, covered with colored gels, behind a sheet of frosted acetate as a background. The silhouette was prevented from being pure black by using a sheet of window glass to reflect the blue and magenta colors of a spray-painted piece of seamless background paper into the image.

"Shot with tungsten light, KODAK EKTACHROME 160 Professional Film (Tungsten), and a 35 mm single-lens reflex camera."

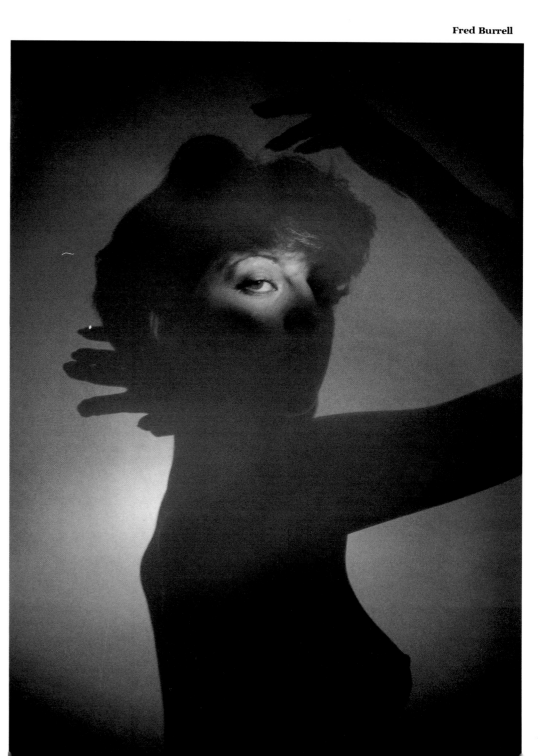

then change the color, using a diazo-like material. The photograph will work when it conveys a heightened emotional sense of a person who is objectively recognizable.

To depart from usual procedures, it is necessary to know what the usual procedure is and how it affects the visual message of the picture. Sharp focus allows the fascination of almost infinite detail in a face. Soft focus allows the imagination to react with the subjective impression of the subject. Darkness is moody. Lightness is cheerful. These are generalizations, good guidelines upon which to construct a photograph.

The correct technical procedure for using cameras, film, and chemicals is thoroughly conveyed by manufacturers. Their instructions tend to let us see the world as if we were sitting still with nothing more elaborate in our minds than to stare at whatever is in front of us. Yet we lookers at photographs and users of camera equipment are emotional people. Some of us wear eyeglasses so our natural vision is not 1/250 second at f/22. We move as we play with our children. We get too close to our loved ones, and in fact, see them out of focus.

These are truths of life and vision. It may be necessary for the deliberate photographer to know how to show this to satisfy his own sense of vision. Perhaps it is a deliberate "mistake" to depart from the "correct" way of making photographs that leads us to this vision.

If you have let a camera strap or a finger come in front of the lens, there will be a dark blurry shape in your picture—a mistake. But if that blur were a patch of color—a flower held too close to the lens—whatever you see in focus will be more important because of its detail. A pretty girl's face centered in out-of-focus flowers would be the creative result.

It is necessary to know what caused a mistake in the first place. It needs to be repeatable technically. It needs to be made deliberately and applied to other elements in a picture. Out-of-focus thumb; out-of-focus flower; pretty girl.

As a working philosophy, I find it is most effective to alter only one aspect of a picture and leave the rest normal. In portraiture, it is important that there be a realistic likeness of a person. But there may be one feature—perhaps the eyes—which is the most striking in a person. In that case, the eyes can be illuminated by a spotlight while the profile shape of the head becomes a silhouette against a glowing color background.

Light can be used selectively to emphasize red hair or the upper half of a face.

As an extension of exaggerating certain features, relevant objects can be placed in

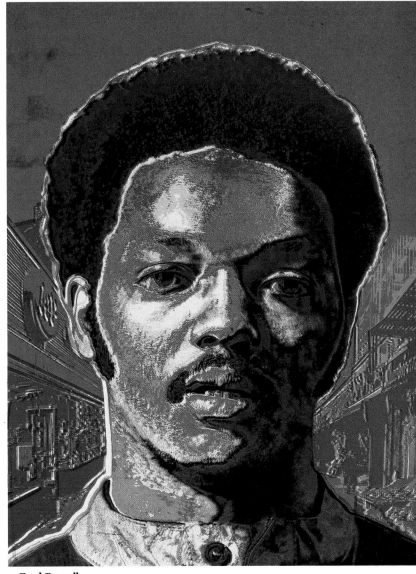

Fred Burrell

"This portrait of black leader Rev. Jesse Jackson was executed for Time Magazine. *A poster style was used to suggest a powerful presence and this was accentuated by the strong perspective lines of the background supermarkets, which were an important locale in Jackson's civil-rights efforts. The supermarkets were shot separately and added to the original transparency of the subject.*

"The posterization was a multistep process. The transparency was enlarged onto 4 sheets of Kodalith film over a wide range of exposure times. These negatives were each contact-printed back onto fresh sheets of Kodalith film to make a set of positives. These tone-separation records were then combined on a mix-and-match basis and contact-printed on a color diazo material. A total of 12 layers of diazo material were ultimately combined to make the photograph shown here. The process allows for great control since each color is on a separate sheet of transparent plastic."

A Creative Approach

"This portrait of a retired sea captain is a double exposure of a transparency of the captain and a model of a sailing ship that we built together.

"The model was placed on silver Mylar plastic sheeting, properly wrinkled, and then rear-lighted through frosted acetate sheeting. The orange and red colors were colored gels in front of the lights. Some of the light gray tones in the original transparency of the captain were allowed to remain in place, to suggest mist and clouds, when the transparency was rear-projected to make the double exposure."

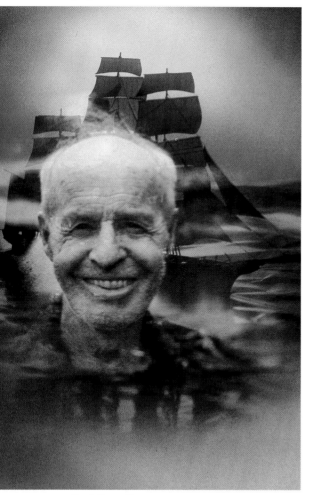

Fred Burrell

Fred Burrell

"This is a portrait of Nixon's press secretary, Ron Ziegler. It was done for Time Magazine *and I tried to indicate the mystery and complication of seeing the shape of events through the personality of a spokesman. A copy of the original transparency was made on Kodalith film and was slightly bleached in potassium ferricyanide and potassium bromide. This resulted in a hazy gray edge to the solid black areas of the portrait. The copy was then hung in front of a still life of wooden blocks upon which were painted both flesh tones and black-and-white abstract patterns. The final photograph was made under tungsten illumination on KODAK EKTACHROME 160 Professional Film (Tungsten) with a Hasselblad camera."*

front of the subject's face — a beaded curtain, a sari, or simply out-of-focus black or white shapes.

An aspect of nature can be added to a portrait done in a studio. Real autumn leaves can be placed in front of a black-and-white portrait print and lit to resemble sunlight, then copied in color. A double exposure of clouds is appropriate for a portrait of a girl. The clouds can be brought into the studio by projecting a slide of them onto a rear-projection screen and photographing them after making the portrait exposure. A fan can blow the subject's hair, which is held in sharp focus by strobe exposure, to give a windy-day look. Fire and ice can be set up as still-life subjects in front of the portrait subject. Objects which relate to a person's occupation or interest also can be double-exposed into the portrait of the person.

Pure design — shapes having no representational association with the person — can be incorporated in a portrait. The effect is one of abstracting the surroundings, but not the subject. Such pictures go well in a modern home or apartment.

There is a boundary of definition — perhaps it is a wandering one — between a portrait and an abstract piece of art. It is possible and interesting to pictorially break up a face so that it is difficult to tell whether it is a picture of a person, much less an individual. The extreme of this procedure crosses the boundary beyond portraiture. My rule of thumb is to keep the majority of elements in a photograph realistic and representational of the person. Any alteration from realism in other parts of the picture then becomes clearly a comment or striking extra feature of the portrait. It makes an unusual picture of a person, not a picture of an unusual person.

A shutter speed that is too slow can either result in a blur or a blurred person. If it is the former, it is a failure; if it is the latter, it could be a portrait of an athlete in action, but technical experience and control are what keep it a portrait.

Portraits that contain a "mistake" which has been made into a disciplined technique, are usually quite striking. They provide a fresh and new look at their subject.

Try it. You don't have anyone to please except the man who says, "I don't know much about art, but I know what I like."

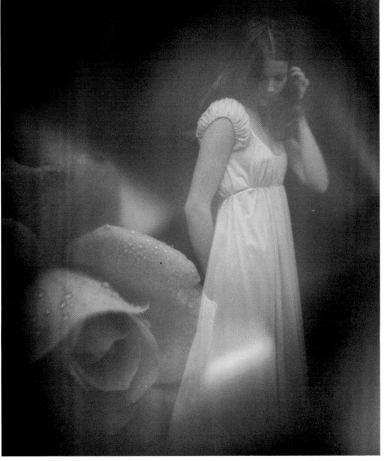

"The girl in a pink nightgown with a pink rose is a double exposure. The rose was photographed through a magnifying glass, which softened the image. Both exposures were made in the studio with tungsten light using a 35 mm single-lens reflex camera."

Fred Burrell

Fred Burrell

"This romantic simplification of a girl's face is a double exposure of rear-projected clouds and her own profile, as she posed in a dark studio in the light of a low, gel-covered tungsten lamp."

111

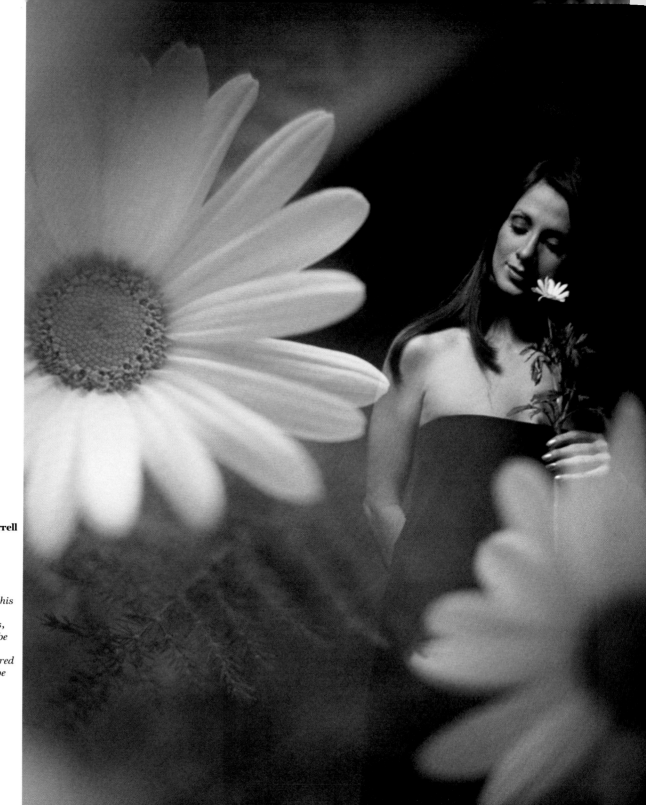

A Creative Approach

Fred Burrell

"Perhaps it is a deliberate 'mistake' to depart from the 'correct' way of making photographs that leads us to this vision. If that mistake were a flower held too close to the lens, whatever you see in focus will be more important because of its detail. A pretty girl's face centered in out-of-focus flowers would be the creative result."

"This triple view of the same subject was inspired simply by the model returning to the studio to see some 11 x 14-inch prints of herself. The black-and-white portrait print was laid against black velvet. The print was ferrotyped and reflected the model's face from a third angle—an addition that I didn't notice until I saw the processed film. Shot on KODAK EKTACHROME 160 Professional Film (Tungsten) with tungsten light and a 2 1/4-inch SLR."

Fred Burrell

"As a large portrait for a modern house, a pattern of triangular shapes focusing on the face was double-exposed with a lovely subject. The range of colors comes from a wheel of theatrical gels placed behind frosted acetate sheeting. The colors affect the subject's flesh tones more in the shadow areas of her face and only minimally in the fully lighted areas. They also serve to soften the pattern that appears over her.

"A studio shot, tungsten light, KODAK EKTACHROME 160 Professional Film, and a 35 mm SLR."

Fred Burrell

A Creative Approach

Fred Burrell

This has become a psychedelic classic. The composition starts with all attention on the subject's eye. Psychologically, the pattern seems to refer only to her gaze. But as the spiral expands, it delineates her forehead, the curved plane under her eye, her nose, and her jaw line. The spiral reverses itself to fill in the dark area of her hair and finally is lost in the dark surround. So, after the compelling circular pattern attracts the viewer to her eye, it eventually defines her entire face.

The photograph was initially shot with black-and-white film. Tone separations were made on high-contrast film and contact-printed onto color diazo material through a spiral negative. The spiral negative was rotated slightly or reversed between exposures. The final transparency consisted of eight layers of material.

The spiral pattern negative is one of hundreds of such scientific and optical items available for experimentation from Edmund Scientific Company, 300 Edscorp Building, Barrington, New Jersey 08007.

Roger Bester

And finally, encompassing the ends of the spectrum of available subjects for the portrait photographer, here is a whole gamut of expressions. This was done just for fun. The young lady is model and actress Brooke Shields who is very much at home before the camera. The elderly gentleman, the late Brazilian author Erico Verrissimo, seems to despair the antics of the younger generation. Even the choice of film and paper makes a statement of difference. The warm, sunlit colors of the large color portrait contrast with the cool blue-blacks of the strip of black-and-white mug shots. There is no other medium in which an artist can make such a statement of contrasts with so much ease.

More Information

A generation or two ago, information regarding the specialized techniques of portraiture was very hard to come by. Successful portrait photographers regarded their own methods of producing photos as highly guarded secrets. The only practical way of learning the secrets of a master was to be his apprentice.

Happily, those days are past and most photographers willingly discuss their work and their techniques today—witness this book. They also conduct workshops and seminars across the country, many of which are sponsored by photographic manufacturers and processing laboratories. Summer-long schools or week-long courses are becoming more popular as the art of photographing people grows. Many portrait artists publish their own technical manuals, whether in book or cassette tape form. Camera clubs throughout the world sponsor guest lecturers.

In the United States, the Professional Photographers of America is an excellent source of information and promotes the sharing of photographic ideas. The national organization features a monthly magazine and also sponsors a unique summer photography school. The Winona School of Professional Photography holds a series of one-week courses of instruction in almost every phase of photographic endeavor. (Several of the photographers whose work is included in this publication are regular instructors at Winona.)

The PPofA has regional and state chapters, as well as some overseas affiliates that perform similar functions and, like the national, have annual conventions featuring photographers as exhibitors and lecturers in the field of portraiture, as well as commercial, industrial, press, law enforcement, and other forms of photography. The trade show, particularly at the National Convention, features the newest equipment displayed by photographic manufacturers. Information regarding any of these activities can be obtained from the Professional Photographers of America, Inc., 1090 Executive Way, Oakleaf Commons, Des Plaines, Illinois 60018.

Eastman Kodak Company lists over 850 titles of photographic information publications (of which this is one) in the "Index To Kodak Information," Publication No. L-5. Single copies are available without cost from Department 412-L, Eastman Kodak Company, Rochester, N.Y. 14650.

A new title in the Kodak list of publications of particular interest to readers of this book is Kodak Publication No. E-99, Picturing People, *which further discusses photographic portraiture.*

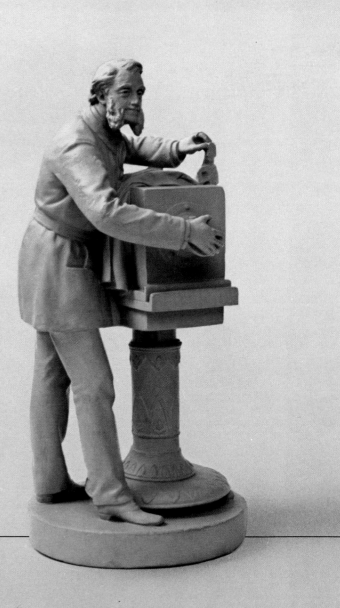